GUY COHELEACH'S
ANIMAL ART

*To Pam,
who found out
how dull
it wasn't…
and to George,
Coleen, Hugh
and Little Guy*

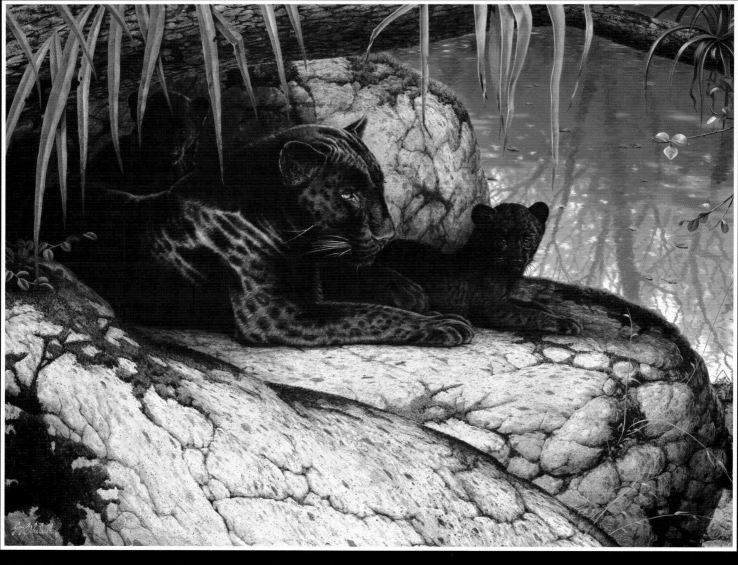

Black Satin (Leopard Family) • Acrylic on board • 30 x 40 • 1992 • Print: 1992

GUY COHELEACH
ANIMAL ART

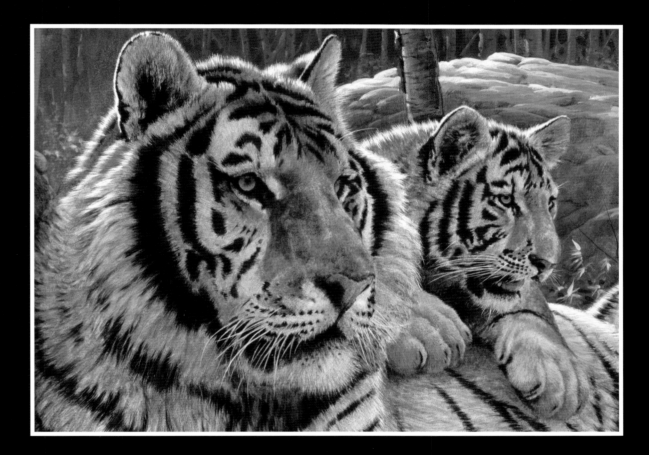

TEXT BY TERRY WIELAND
INTRODUCTION BY ROGER TORY PETERSON

DDR PUBLISHING

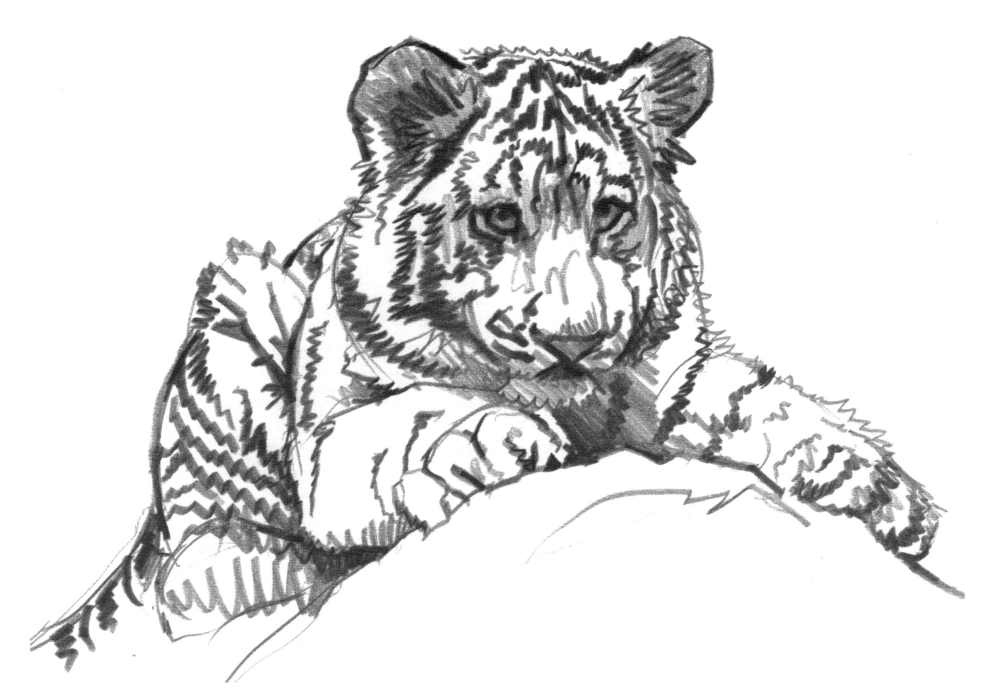

Guy Coheleach's Animal Art was designed and published by DDR PUBLISHING, P. O. Box 221095, Cleveland,
Ohio 44122.

Printed and bound in the United States of America by Activities Press Inc., Mentor, Ohio.

This book is printed on recycled paper.

ISBN 0-9639480-0-8

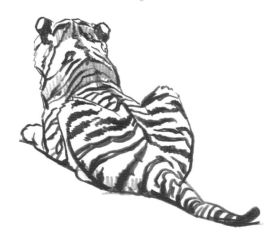

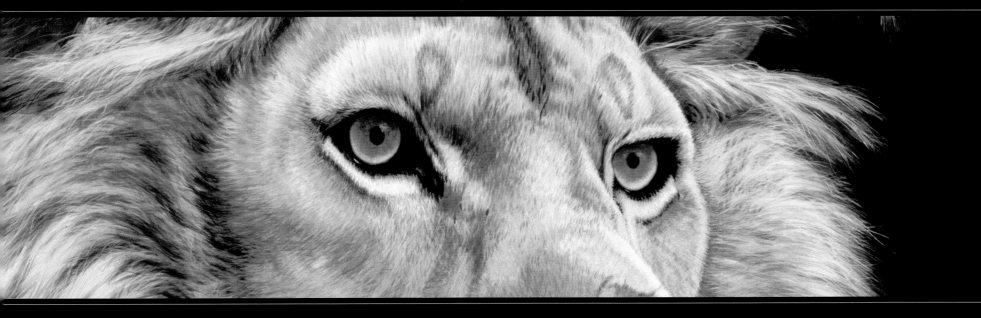

TABLE OF CONTENTS

FOREWORD
BY GUY COHELEACH

Last year I was invited to participate in a group show out west. Having no previous experience with this particular gallery I inquired as to what style of my painting they would prefer to exhibit. They wanted very detailed portraits of big cats and birds of prey of course, did I do anything else? I was surprised at their response. Surely the greater body of my work must be described as impressionistic or painterly with no detail at all. Yet they were completely unaware of this. It has since been pointed out to me that most people know my work only from the many prints that I have had published. Anyone in the print market knows that to be successful selling art reproductions, of wildlife anyway, the image must be extremely detailed to be popular with the general public. Hence the lopsided perspective I suppose. I certainly hope that a tour through this book will provide a more balanced view of my work, and of course that you will enjoy the journey.

Guy Coheleach

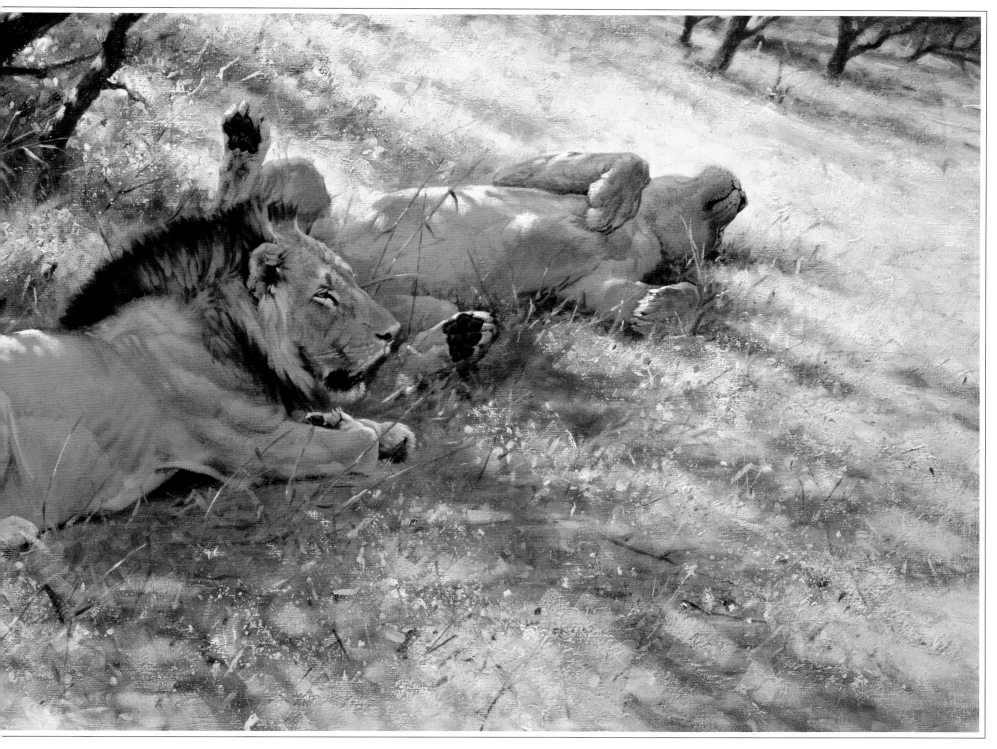

Pause (Lions) • Oil on canvas • 24 x 44 • 1989

INTRODUCTION
BY ROGER TORY PETERSON

Guy Coheleach and Roger Tory Peterson at Leigh Yawkey Woodson Art Museum, 1990.

Guy Coheleach became hooked on birds when he was a boy in Baldwin, Long Island. He tried to catch gulls and peregrines on the south shore of Long Island, buried in the sand with a peach basket over his head and bait in his hands. He had cobras and rattlesnakes in his basement which his mother had to cope with when she was doing the laundry. On one occasion, a cobra got loose. His very tolerant mother just took a broom and swept it aside.

Coheleach studied at and graduated from Cooper Union, where he found himself at loggerheads with some of his instructors who were more into abstraction and subconscious comment. Coheleach took what he thought was valid from his instructors but went his own way as a realist. I think this is very important. Basically, Cooper Union prepares students for design and in a way there is no better training for a representational artist. He spent a few years in the commercial bullpen, illustrating mail order catalogs, designing candy boxes, and things like that.

But it was Don Eckelberry who changed his life. Don was also one of the recipients of the (Leigh Yawkey Woodson) Master Artist award, and knows more about how a bird is put together than anybody I can think of. They met at the Explorers Club, where Guy was the youngest member at that time. Guy said he would rather paint wildlife but probably could not make a living at it. Don said, "Not so," and told him that he had been turning down commissions right and left. Wildlife art was then in the ascendancy, so Guy decided to risk it.

I suspect that I also gave Guy a boost at the right time because I was the art editor of the National Wildlife Federation stamp program. On speculation, Guy sent us four mammal subjects for consideration, each one in a very different style. I clearly remember that we took two, and then we commissioned him to do others. We soon found that he was as good at birds as he was at mammals.

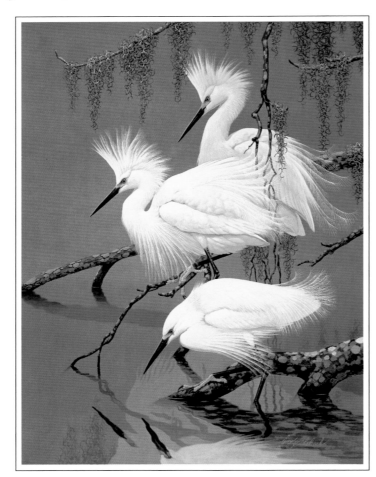

Snowy Egrets • Gouache on Board • 34 x 27 • Print: 1969

From that point on, he really took off. He did not simply climb the ladder of success, he ran up it!

He won numerous awards, and honors were heaped upon him, culminating in an honorary doctorate from William and Mary College. He is one of the few living recipients of the coveted Master Artist Medal of the Leigh Yawkey Woodson Art Museum, and he has been awarded no fewer than six Awards of Excellence at the Society of Animal Artists' annual exhibitions.

Fundamentally generous, Guy Coheleach has contributed his prints and originals for the fund raising efforts of a number of conservation organizations. Sometimes I think artists are called upon too much to help others, but most are generous — Guy particularly so. Although he may seem rather street-wise and macho at times, he's really a very sensitive person and a devoted family man. I maintain that he is an artist first, with a businessman's instincts. By getting proper prices for his work he has helped all of us to raise prices, and we all thank him for it. Today, really competent wildlife artists can make a good living.

Guy is perhaps the most versatile and, in a sense, the most professional wildlife artist I have known, because he can paint in any medium and in almost any style. He can work very loosely and also very tightly. "I must change around to keep myself from being bored,"

he says, and that is why you cannot always tell a Coheleach painting. He can work in so many ways. I remember a night some years ago when I attended a bird art show put on by a gallery in Kentucky. While sitting in the lounge, I spotted what I thought was an Audubon that I had not seen before. There were others which were new to me, stylistically. At least one looked like a Francis Lee Jacques. Crossing the room, I found they were all done by Coheleach. Later, I asked him when we were going to see the real Coheleach.

Although Guy can paint with equal facility, a kinglet, an elephant, or a striped bass, he is excited about the predators, the birds of prey and the big cats. I recall once when we visited a reserve in the hills of northern New Jersey where they were trying to propagate Siberian tigers. We went into the forest with an Australian trainer who had one of the tigers on a leash. Guy was ecstatic. He studied the animal at eyeball to eyeball range. Suddenly the trainer said, "Get into the truck, quickly." He had detected something in the tiger's yellow eyes. He wrapped the tiger's iron chain around a tree while we got into the cab of the truck. He then unwound the chain and ordered the tiger into the back of the pickup. I have often wondered whether the tiger saw in Guy a competing predator.

Once, he was knocked down by an elephant, and therefore has great respect for these big animals. And no one paints a charging elephant better than Guy Coheleach. He really gets into his subject matter. In fact, there was a Guy Coheleach portrait of a charging elephant in the White House. In New York City, there is a restaurant called *The Girafe*. As you go up the stairs, you see a terrific mural. The higher you climb, the more of it you see. There is a lovely little baby giraffe at the foot of the long legs of the mother. Your imagination carries you up the stairs. I think it is a marvelous mural. I told the proprietor I knew Guy Coheleach, but he did not give me a free meal.

Guy and Pam (his wife) are obviously in love with Africa. His first visit came about by his winning the novice division of the Winchester National Trap and Skeet Championships. They visit Africa often. Both love fishing, especially salmon in Alaska and tarpon in the Keys. When not travelling, they divide their time between their lovely home in northern New Jersey and a new home in Florida, migrating seasonally like the birds.

Striped Bass • 18 x 22 • Print: 1968

Guy's book **The Big Cats**, published by Harry Abrams, was picked up by the Book-of-the-Month Club. His **Coheleach** sold out in both editions in a few weeks. You might say that Guy is a Renaissance man because, in addition to all these things, he's a world-class chess player, and I could not begin to list all the other areas in which he excels. Guy is one of those fellows who can do almost anything. He has certainly come a long way since he did those National Wildlife Federation stamps for us.

Roger Tory Peterson
Old Lyme, Connecticut

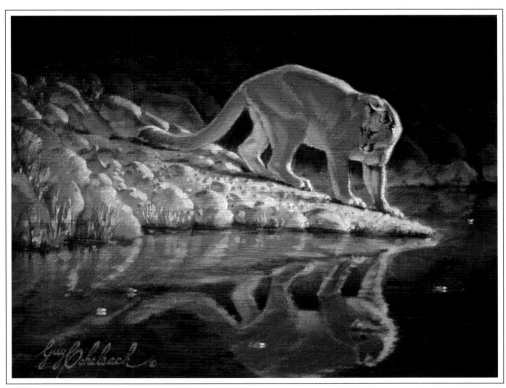

Bottom Canyon Cougar • Oil on canvas • 9 x 12

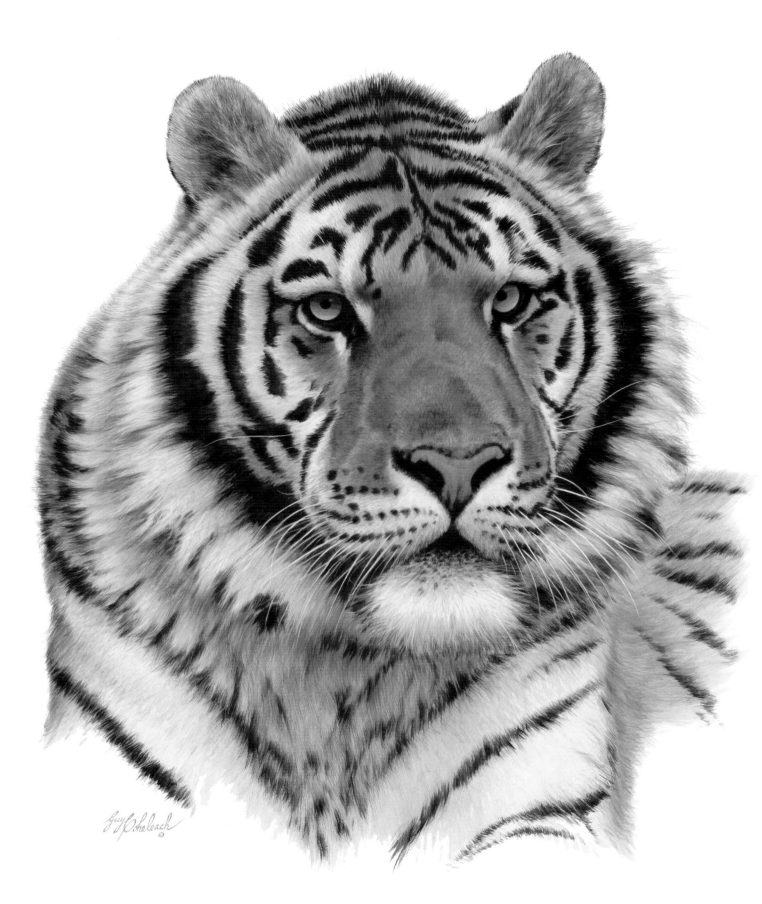

The Siberian tiger is one of Coheleach's favorite animals, and he uses this rendering of a Siberian tiger head on his personal stationery.

If you are reasonably good at rendering — that is, painting very tight and detailed — then a portrait like this is relatively easy to do.

Siberian Tiger Head
Gouache on
illustration board
34 x 28 • Print: 1981

NEW JERSEY'S SHELTERED GROVE

*My parents never had alot of
material things to give us…
but there was never any doubt
in any of our minds that
they loved us dearly.*

Bernardsville, New Jersey, is a well-bred little town, one of dozens dotting the affluence belt that surrounds New York City.

At one time, it was farming country. Today, because it is only an hour's drive from Manhattan, the farms are gone, divided and subdivided into building lots — if you can call five acres of real estate selling for sums well into six figures a building lot. The country is heavily treed, the highways are narrow, twisting, and scrupulously clean. In reality, they are little more than extensions of driveways that lead, ultimately, to Manhattan skyscrapers.

In North American terms, this is old country, settled for hundreds of years. Old country and old money — and it shows. The houses are mostly big and even older than the trees that surround them. Right here is the reason they call New Jersey *The Garden State*.

In many ways, it is the last place you would expect to look for a man of Guy Coheleach's daredevil reputation. Alternately a sky diver and tournament chess player, champion skeet shooter or wisecracking New York street kid, Coheleach would seem (at first glance) more at home in either a Manhattan penthouse or a Tanzanian safari camp — anywhere but well-bred New Jersey. But those are Coheleach's public personas, donned (so it seems to me) to screen the private Coheleach from public view, just as the tall trees along the roads protect the big Jersey houses from the idle gaze of those who pass by.

Guy Coheleach's own house lies about three miles from Bernardsville, down a succession of ever-narrower and more winding roads. Signs are few and far between. The Coheleach house is one of those deceptively shaped buildings that seems small when you first see it as you come around a bend in the drive, with its twin garage doors staring, fronting for the rest of the house like

the eyes of a cubist tadpole. You never see how large it really is because there is no vantage point from which to view the whole. In front and behind, the trees come in thick and close. There are no neighbors visible through the hardwoods rising on the hillside behind and descending the hill in front, and the view from the long terrace is of endless trees.

Coheleach's street kid mannerisms are contradicted by his house, by the James Clarke bronze rhino in the vestibule and a Clarke Cape buffalo nearby, the Wilhelm Kuhnert lion over the mantelpiece, the Dennis Anderson bronze Cape buffalo head by the window staring down his nose at you as you enter, looking like William F. Buckley about to address a liberal, looking, as Robert Ruark once said, "Like you owe him money." The buffalo almost manages to dominate the room even when Coheleach himself is in it. This house is a long way from Coheleach's roots on Long Island.

I first saw the place on a day in early fall when the leaves were starting to turn and the crisp air already carried a faint whiff of wood smoke. We were sitting on the terrace, sipping and chatting, when Guy abruptly changed the subject.

"Ever drive a Jaguar E-Type?"

"No. I used to dream about it, but I've never driven one."

"You can drive, though, huh?"

"Sure."

"Well, my problem is this. I have a Jaguar that was in for some work and I have to go pick it up. Mind coming with me and driving it back? We got time?"

"Sure, we can talk in the car just as well as here."

The repair shop was somewhere beyond the Great Swamp Refuge, a wildlife sanctuary just outside Bernardsville.

"I bought the car a few years ago," Coheleach told me. "I saw a picture and had to have one. So I go into the dealer and I buy one with a manual transmission, which we weren't used to. Well, the very first day we have it, it gets banged up, $800 worth. Put it into reverse by mistake and bang. So I call the dealer and say 'I want a red E-Type with an automatic. You got one?'

"Dealer says he has a white one. 'Paint it red and I'll be down to pick it up,' I said. 'You can't be serious,' he said. 'I sure am,' I said, 'I want a red Jaguar, so paint it red.' Which he did."

That particular Jaguar obviously preferred to remain white, and it took its revenge on Coheleach for the paint job from that day on, doing its best to see that his bank account also stayed in the red.

"It's got about 28,000 miles on it, and most of them were put on by mechanics trying to get it to run right," Coheleach said as we pulled into the mechanic's shop. "Most beautiful sports car anybody ever designed and the engine's fantastic, but the wiring was done by a two-year old."

The Jaguar was crouched in a corner beside the shop, hemmed in by lesser beings, MG's and such, but flanked by a shabby, genteel Bentley that sat there, embarrassed by the rust around her edges and the dashboard tossed into the leather backseat. We collected the key and walked over.

Coheleach eyed the Jaguar. The Jaguar eyed Coheleach.

He slid into the front seat, pulled the choke, and twisted the key. The engine turned once, then again more slowly, then died. Yet again, the sleek and beautiful Jag needed help getting started.

The mechanic had done his work, however; a quick boost and the E-Type was purring away, smoke curling out from under the engine cowling ("I just can't find that oil leak, Mr. Coheleach, but don't worry — it's just a drop or two on the manifold, and only when it's not running.") I was shepherded carefully home, Coheleach leading the way in his less elegant but more reliable Japanese sedan, the Jag's fuel gauge reading *empty* all the way, the warning light on, the

choke out to keep it running. It had acceleration to burn, though, and was wonderful on the corners.

A red E-type convertible on back roads on a sunny day, with the top down on one of those days when the air is just starting to feel a touch of fall and you could use a sweater, but would rather shiver a little and watch the girls walking down the street. Accelerating through the corners, heads turning as I geared down and feeling the Jaguar's sure grip on the twisting pavement, for 15 glorious minutes I knew how it felt to be young and successful and belong among the wooded old hills of New Jersey.

For a brief moment, I knew how it felt to be Guy Coheleach.

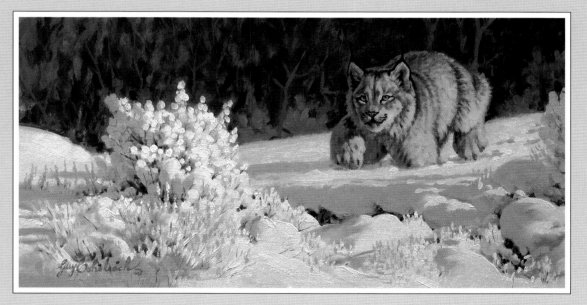

Lynx Prowl • Oil on canvas • 8 x 16

For Coheleach himself, the road to Bernardsville has led through some strange and exotic and frightening locales. It has led through Indochina and the French war with the Viet Minh. It has led through Manhattan and the advertising citadels of Madison Avenue. It has led through Africa, and across the path of a murderous elephant near the Zambezi River. It has led through all those places. But it began on Long Island.

One of nine children, Coheleach was raised in Baldwin, Long Island and went to high school in Brooklyn, and he retains traces of his boyhood in his speech and urchin mannerisms which slip only occasionally.

Magazine articles never tire of insisting that Coheleach's father, Gaetan, was a test pilot of Franco-Swiss origin (the name is pronounced CO-lee-ack), but Guy himself says that to call him a test pilot is an exaggeration.

"Actually, he worked for the phone company, but he did do a lot of crazy things before he was married. I've got pictures of him in airplane crashes up at the Great Lakes Naval Station. I don't know if he was involved in all three of them, but he loved flying and all kinds of crazy things like that. Once he got married, though, and the children came along, my mother said, 'Enough of that, get yourself a job.'

"He faced his responsibilities and got a job with the phone company, and he stayed with them until he died (in 1963). He was on medical leave when that happened. He was going around to see all the kids. We were spread out all over the country at that time — Virginia, Florida, California. He was on his way home when he got caught in a wind storm that wrecked the car and trailer.

"When I realize the sacrifices the man made — coming out of that generation, he never did have a lot of money. Worked days and nights and weekends to support us, and he was just one of those people who never had anything brand new for himself. It's a shame he died before I could do a couple of nice things for him."

"Did you get along well with him?"

"Oh, yeah, yeah. I guess I was in high school before I realized he wasn't God. The thing I remember is, he was so fair. If he ever had a favorite with the nine children, none of us ever knew about it."

While physically close to Brooklyn, the village of Baldwin was most unlike the former home of the Dodgers.

"When I was a kid, we used to leave our doors unlocked. My mother always said, 'there's nothing here for anybody to steal except food, and if they're hungry, they're welcome to it.' My parents never had a lot of material things to give us, which probably bothered them a little, but there was never any doubt in any of our minds that they loved us dearly.

"When you consider that I came home with rattlesnakes and cobras and kept them in the cellar, and all they demanded was that they be kept in clean cages, with fresh water, and well fed..."

This is a piece of vintage Coheleach folklore — the basement full of deadly reptiles.

Even as a child, Guy Coheleach had a passion for other living creatures, and he began to pursue a career as an amateur herpetologist at an age when most other kids are playing baseball. He kept his snake collection at home, and fed them on mice, collected from the laboratories at Columbia University, where he cultivated friendships with doctorate students and even went so far as to do field work for them.

"I don't think I ever had more than five or six snakes at home, and then generally because they were sick and I wanted to keep an eye on them," he says. "But no, I didn't just have a whole bunch of snakes at home. I had all kinds at home — at one point I had a 12-foot king cobra! But I only had him because he had a respiratory ailment. But let me tell you something: When you're injecting a 12-foot king cobra, you do it with great care!"

"I'll bet!"

"And when I think of how serious it could have been...I mean, my mother went down one time and there was a six-foot Indian cobra loose. She got the broom, swept it aside, did the wash and came up and told me, those snakes are going if that ever happens again.

"Now those are understanding parents. You know? They thought what I was doing was at least constructive."

Between field work and trips to Columbia, the Bronx Zoo, and the American Museum of Natural History, Coheleach picked up an immense amount of knowledge about wildlife.

On a bird-watching trip, he discovered Roger Tory Peterson's *Field Guide To North American Birds*, and became hooked on birds of prey. Within two weeks, he says, he knew the Latin name for every bird of prey in the United States. Years later, in 1983, when Coheleach received the Master Artist Award at the Birds in Art Exhibition, he was introduced by Peterson himself as "a Renaissance man...the most professional and versatile artist (I) have ever known..."

He was a natural academic in the only good sense of the word — a kid with an overwhelming curiosity about life around him, combined with an ability to absorb information, file it, and go looking for more. Instead of writing about what he learned, he translated it graphically, filling notebooks with sketches and drawings of birds, animals, and reptiles. Coheleach's artistic talent first surfaced at about the age of 10, scratched, illicitly, onto the covers of school notebooks. He got into all sorts of trouble for it, he says; the nuns did not approve of him defacing books — his or the school's. On the other hand, they recognized something beyond idle doodling and graffiti, and sent notes home with him "not so much to punish me, but just to let my parents know the talent was there."

"Apparently, the stuff was pretty good," he says.

Jimmy Stewart, a long time friend, with Guy Coheleach at Leigh Yawkey Woodson Art Museum, 1983.

And, at Christmas time, he began to receive the materials he needed — a drawing table one year, an oil paint set the next.

"My parents never pushed it," he says, "but once they knew the talent was there and it was developing, they always encouraged it. And you know, one of nine kids and coming out of the Depression, there wasn't an awful lot of money to throw around on stuff like that."

Guy Coheleach drew and painted his way first through grade school, then through high school, ultimately earning a scholarship to the Cooper Union School of Art, near the corner of Third Avenue and 8th Street in the heart of Manhattan.

The year was 1952. Dwight D. Eisenhower took office as the conflict in Korea wound down, the war of bullets replaced by a war of words. In Indochina, French forces stepped up operations against the Viet Minh. And in New York, Guy Coheleach, aged 19, of Long Island, went off for his first year of art school.

It was not a match made in heaven. The wise-cracking realist, fascinated by birds and animals, did not mesh well with the avant-garde, radical, communist, New York East Village atmosphere of Cooper Union. Cooper Union taught only abstract art, and the discussion in the halls was of socialism; Coheleach retaliated by admiring Eisenhower. From the curriculum, he sorted out what was useful to him, and today concedes that much of what he knows of design originated at Cooper Union.

He was also strategically located, geographically, to frequent some of the great centers of New York culture. The nearby Institute of Fine Arts at New York University was one such. McSorley's Old Ale House was another...

"Did I hang out at McSorley's?!? Slabs of liverwurst half an inch thick, slabs of onion, mustard that would peel your lips and the greatest ale in the world. Do I remember McSorley's?

"I go to a lot of fancy bars in New York if I'm entertaining people, but if you really want to enjoy yourself you gotta go to McSorley's."

McSorley's, the previously males-only preserve on 8th Street, a stronghold of pickled eggs and wood smoke and dark brown ale, has been serving beer since 1837, twenty-two years longer than Cooper Union has been serving education. In fact, as the oldest continuously operating ale house in the U.S., it is only six years younger than NYU, and with many more alumni.

"Oh, yeah, McSorley's. I saw Bobby Thompson's famous home run there. Right during school hours. The teacher said to me, 'Ko-latch, you don't seem to have your heart in it this afternoon, why don't you just go down to McSorley's and keep an eye on that ballgame for us and let us know how it comes out when it's over?'

"But God bless him, I always loved him for that, lettin' me go down and see that game, 'cause that was about as dramatic a hit as you'll ever get in baseball. If you like baseball. I'm not crazy about baseball anymore, but I was then, mainly because I didn't like school. Even art school."

It was a relief to both Cooper Union and Coheleach himself when the army reached down and plucked him away to serve his country. At Camp Kilmer, N.J., he was subjected to the usual battery of tests as Uncle Sam sought to find some military skill for which he might be suited. One of these was a test called *pattern analysis*.

An early illustration of a Glass of Beer

"What they do, they show you five patterns. Then they show you a house. You have to tell them which pattern built the house. Then they show you five houses and one pattern, and you have to pick out the house it is for. That sort of thing."

Coheleach was the first recruit in the history of Camp Kilmer even to finish the test, or so they told him. What's more, he got 100 per cent right. Next thing he knew, he was en route to Korea in charge of intelligence for a battalion of combat engineers.

It was 1953. While the students at Cooper Union argued painting and politics, their former schoolmate fretted with his unit in an almost peaceful Korea. Meanwhile, French forces in Indochina planned a daring coup against the Viet Minh. In November, six battalions of French paratroops seized the valley of Dien Bien Phu, 500 miles northwest of Hanoi, and prepared to begin the decisive battle of the war.

In early 1954, Vice President Richard Nixon toured the new fortress; in May, the Viet Minh launched their attack. Coincidentally, Guy Coheleach's unit was ordered back to Hawaii. Coheleach himself, however, having made the mistake of displaying

an aptitude for his work, was sent to Indochina on loan to the French. His job: To help with evacuation routes for the French forces pouring back down the Red River into Hanoi from the highlands in June, 1954, one month after the fall of Dien Bien Phu.

"I must say, it was interesting work," Coheleach now recalls dryly. "The country was jungle and mountains, and really impassable except for the roads. Our job was to fly in low over the countryside and examine the bridges to see if they were strong enough to take heavy vehicle traffic."

For Guy Coheleach, the notorious Red River of Indochina was one more stream lying between Baldwin, N.Y., and Bernardsville, N.J. One year and nine months after answering the call, the veteran of Korea and Indochina returned to Cooper Union to complete his interrupted course of study. After his brush with real-life realpolitik as practiced by the North Koreans and Ho Chi Minh, the undergraduate socialist debates in the corridors of Cooper Union seemed trivial beyond comprehension, and Coheleach graduated and departed with great relief.

From the East Village, Guy Coheleach paddled uptown, 22 years old and on his way to a job on Madison Avenue, in a catalogue house, applying his hard-won artistic expertise to the drawing of brassieres and can openers (says one writer) and candy boxes (says another) or in fact anything they wanted him to (says Coheleach himself) for the munificent sum of $55 a week. In truth, looking back, it is easy to trivialize both the job and the salary, but in 1955 it was a good job at decent money. Like Hemingway and Ruark crediting their early experience in journalism for their discipline and ability to meet deadlines, Coheleach credits Madison Avenue with teaching him a lot about design and a lot more about the realities of painting for a living — the need to sit down, day after day, and produce.

Offered a $10 raise, Coheleach declined and took a job as a magazine illustrator at $150 a week, which he says he thought was "all the money in the world." However, it set in motion a train of events. Coheleach was admitted to the Adventurers Club of New York, the youngest member ever, and then elected a fellow of the much more prestige-ridden Explorers Club. He went one day in 1962 to hear a talk by Don Eckelberry, one of North America's foremost painters of wild birds. The lecture and the conversation afterwards ignited a friendship which has lasted to this day, and propelled Coheleach a giant step closer to leaving the world of commercial art and becoming a real artist — a wildlife artist.

One thing he learned from Eckelberry was, there was money in wildlife art; one thing he did not learn immediately, however, is that the money was not there just for the taking. Having quit his illustrator's job at $15,000, he watched his income return to its former level of $5,000 — a tough drop to take, given Coheleach's

love of a flamboyant lifestyle — and he was soon scrambling for work as Ma Bell moved in to disconnect his telephone and everyone except bill collectors steadfastly refused to beat a path to his door.

Enter, once again, Don Eckelberry. Almost as if laying down lessons in life, one by one — teaching first that wildlife art could be a career, and second that one had to earn it — he returned to give lesson number three in the form of the helping hand up the ladder that every artist receives, and later every artist owes in some measure to those who come after. Approached to do paintings of birds for a calendar, Eckelberry pleaded overwork and suggested they commission Guy Coheleach to do it instead. He backed his confidence in the young painter's work the best way he could. He told the client that if they were not satisfied with Coheleach's work, then he, Eckelberry, would re-do the calendar free of charge. "I am," Coheleach says, "forever indebted to him for that support." Needless, perhaps, to say, Eckelberry was not called upon to fulfill his promise. Coheleach's work was perfect. His career was launched.

Well, sort of launched. One calendar does not a career or even a lasting reputation make. Coheleach knew he needed to follow up his success immediately, and decided on a brazen way to do it. His fee for the calendar was $1680, which would have paid the bills for a good long time. Instead of taking his $1680 in cash, he took the entire amount in calendars and mailed one to every single art studio in New York City!

It was a move of stunning audacity, under the circumstances. It is much like the famous story about Milton Greene, the brilliant New York photographer and later companion of Marilyn Monroe, who early in his career reached a similar point of desperation after striking out on his own. On the verge of eviction for non-payment, Greene took his last few bucks and threw an all-night, all-out bash to which he invited all the major movers in New York magazine circles. When the hangovers cleared, Milton Greene found his career rejuvenated, and he never looked back. In the Big Apple, in those days, artists and photographers like Milton Greene and Guy Coheleach knew how to get attention.

In Coheleach's case, the "Hey, look at me" calendar mailing paid off, and for the next 10 or so years, he pursued his career and enlarged his following, noting several milestones: His work appeared in **Audubon, National Wildlife,** and **The Saturday Evening Post,** among others; his originals were acquired by private and public collections and displayed, among other places, at the White House, the National Collection of Fine Arts, and the Corcoran Gallery. A commission for a poster led to a burgeoning print career, and the founding of Regency House Art, his own company to market his prints. He even exhibited in Peking, one of the first post-war American artists to do so.

His private life burgeoned as well. He acquired reputations in various fields — jumping out of airplanes, playing tournament-level chess, shooting championship-level trap and skeet. He married Patricia Arlene (Pam) McGauley, a Long Islander of Irish descent, and they had four children.

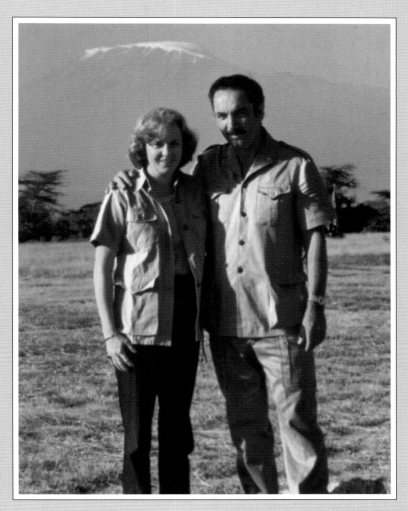

Pam and Guy at Kilimanjaro, 1977

Overleaf:
Rariton Feeder (Red Fox) • Oil on canvas • 36 x 72
Print: 1986

The smallest brushstroke on this three by six-foot canvas was made with a half-inch bristle brush. How long would it take to do such a painting?

It takes about 30 years to learn how; then it takes about a month to do the pencil drawing, and another three or four weeks filling in the colors.

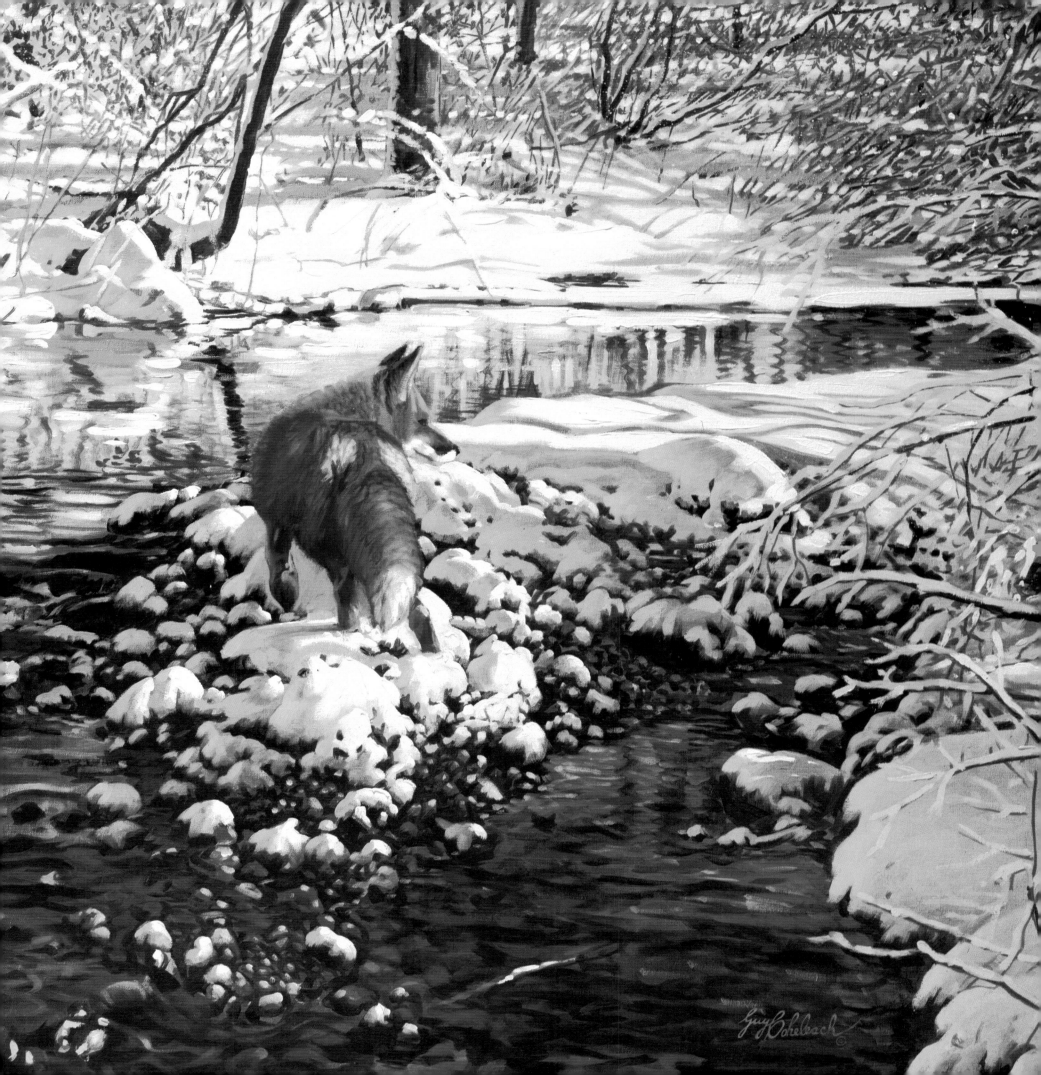

Lion, Acrylic on board • 40 x 30

Lioness, Gouache on board • 20 x 26 • Print: 1978

Guy at booksigning, 1982.

In 1966, an event of seemingly trivial importance in his long train of accomplishments occurred: Coheleach won the Novice Division of the Winchester National Trap and Skeet Championships. The prize was a trip to London, England. Having had enough of London after just a few days, Coheleach hopped a plane to Africa. What he saw there changed his life and his career. It was the beginning of his African period, and his real blooming as an artist.

Coheleach fell head over heels in love with Africa's big cats — the lion, the leopard, the cheetah — and in 1982 he published his masterpiece: *The Big Cats*. More than a collection of first-rate wildlife art, *The Big Cats* is a textbook on the world's great feline predators. The text is a scientific treatise on the natural history of cats, from the mechanical workings of their retractable claws to their antecedents in the dawn of time, to their present day range, mating habits, and prospects for survival. Published by Abrams, of New York, *The Big Cats: The Paintings of Guy Coheleach* was a Book-of-the-Month Club selection, sold out quickly in first edition, and has since come out in a second edition as well.

His African work led to academic recognition: In 1975 he received an honorary doctorate in arts from the College of William and Mary and a scholarly analysis of his work by Dr. Scott C. Whitney in the *William and Mary Review*. In 1983 came his Master Artist award and introduction by Roger Tory Peterson; in 1985, Coheleach was named Wildlife Artist of the Year by the National Wildlife & Western Art Collectors Society.

Behind the scenes, however, Coheleach's life was rocky. In 1975, the year of his honorary doctorate, Pam and Guy Coheleach's youngest son, Guy Jr., was killed by a hit-and-run driver on Long Island. "It was," he says, "the real turning point — one of the times that makes you realize what is important and what is not."

In the early 1980's, life in the Coheleach abode in Bay Shore, Long Island, received a shock of a different kind. The tax man arrived with what was, to Guy Coheleach, some seriously unreasonable demands.

"Taxes! They wanted me to pay six and a half per cent of the market value of my house every year, just in taxes! Can you believe that?"

"Who was going to determine market value?" I asked, always interested in the mechanics of such a thing.

"Not me, that's for sure."

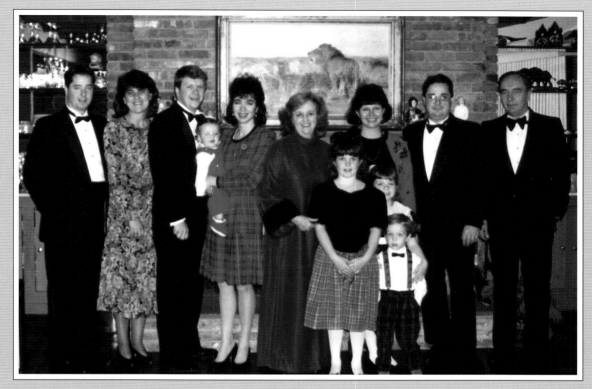

Hugh, Ilona, Bob, Coleen holding Keith, Pam, Robin and George with Lauren, Ashley and Matthew in front of them, and Guy.

So the Coheleach's departed for Stuart, Florida, and Long Island lost one of its resident artists, a man who had been made practically an artistic institution by the local press. Long Island's cultural loss was a financial loss for a few of the local saloons — Popeye's, Vinny's, and Codfish Bob's being his favorites. According to Coheleach, his wife Pam was not sorry to see him deprived of the waterfront company he loved, and together they fled to Florida.

"Great place to work, Florida, but it's impossible to take it seriously. How can you be serious when you go to work every morning in shorts? Like California, only not so weird."

In Stuart, Coheleach adapted as well as he could, going to work each day in shorts and sandals and pursuing another passion: deep sea fishing. But his absence from New York was shortlived. After just two years, Pam Coheleach was tired of Florida, tired of being away from the amenities of New York City she had grown up with, such as Lincoln Center, the ballet and the art galleries, but mostly tired of being unable to see her children and just-arrived grandchildren without having to mount a major expedition every time.

"We still have three kids," Coheleach said, "and they're all in the New York area. Pam wanted to be close to them and one day she said to me she was moving back and I could come or I could stay."

He came, and together they retraced their steps north, but not to over-taxed Long Island. Instead, they settled near Bernardsville,

within easy distance of their two sons, George and Hugh, and daughter Coleen. It is worth noting that all three are pursuing successful careers: George has an MBA, and is married with three children. Hugh, the youngest, was then in his early twenties, had a college degree, and was just embarking on a career in the investment business. He is now married. Coleen, with a masters degree in education, teaches handicapped children. She is also now married, with one child.

Still, memories of the son they lost haunt Coheleach, evident not only in his words, but in what he does not say.

"A thing like that changes your way of thinking completely. Things that used to matter to you don't matter at all anymore. Things you took for granted become unbelievably precious. So we moved back here. Now we get to see George, Hugh and Coleen and their spouses all the time, and our four grandchildren. On top of which, I really like the country up here."

Coheleach was then 52 years of age. It had been a long journey, from Baldwin, Long Island to Bernardsville, New Jersey, by way of Hanoi and Madison Avenue, Nairobi and Stuart, Florida.

The new Coheleach residence was a sprawling house, nestled on a sheltered New Jersey hillside, safely screened from the road by a grove of tall trees, where the white-tailed deer come down to feed.

Later, we went driving through the countryside (not in the Jaguar), looking for nothing, just driving to look. The roads there follow the contours of the land, over streams, around lakes and hills, connecting myriad little towns each much like the last, surprisingly uniform in the front they present, small and not getting larger, providing amenities for the people around — a well-bred bar, gasoline, a liquor store, books, antiques, nice restaurants. They have no aspirations to big citydom. New York is The City. But this is where people come to live.

We stopped at a small town pub, in Gladstone or maybe it was in Peapack. We parked beside a Jersey Jeep: A four-wheel drive Mercedes adventure car. The ultimate Yuppie 4X4. The pub had dress regulations: All gentleman must be wearing *shirts with collars.* Fortunately, I am. Shoes, too. There was a lineup for tables but there was room at the bar.

The piano player was getting a draft beer in a goblet the size of a chamber pot, before sitting down and striking up some Scott Joplin. Coheleach was transported.

"How I love this music," he said. "Wish we had time to take a run up to Long Island and I'd show you some real good places. There were some saloons I used to hang out in up there. Waterfront places. Really rough. Popeye's. Vinny's. Codfish Bob's. Used to go over there in the afternoon after I finished working."

"I know if we went up today we'd never get back tonight. Five minutes after we walked in we'd have drinks lined up for us from here to the wall."

Coheleach's wife hated him going there, he said, and wondered what possessed him to hang out in those places.

"I felt at home there. There's no pretension at all. None. You are who you are. Period."

One of Coheleach's pet hates is wearing a tie. At New York's famous speakeasy, *21,* a tie is required.

"I always took the worst, ugliest tie I could find to put on when I went there," he says. "That's if I was going alone. If I had someone with me who would be embarrassed, I wouldn't do it."

Actually, one of the better-known Guy Coheleach stories takes place in *21.* He went there for dinner one time feeling particularly peckish and in a mood for lamb. Knowing *21* is famous for the quality of its lamb chops, if not for their size, Coheleach ordered eight.

The waiter, snotty to a fault: "Eight orders, sirrrrr?"

"Eight lamb chops," Coheleach replied.

"Yes sirrrrr, lamb chops. Eight orders?"

After going through this about three times, Coheleach finally had enough and said, all right, have it your way, bring me eight orders.

"I thought there were two chops to an order. Turned out there were three. So there I was with 24 lamb chops sitting in front of me. Ate every one them! Frankly, that story says more about the size of their lamb chops than it does about the size of my appetite."

We decided to lunch at an ancient mill in the next town. It dates back a hundred years but is now converted to a restaurant and is a little more to our taste, although the pub was nice and the piano player very good. Coheleach took him a beer and thanked him as we left.

Later, drifting along the back roads in the sunshine, we stopped by a stream that bubbled down out of the hills, curving through the trees over a bed of sparkling rocks. We walked beside it, looking for trout. Upstream or down, not a house was visible. We could have been in wildest Vermont, or maybe fishing Henry's Fork, for all the habitation around.

"Do you like it here?" I asked.

"Like it? Yeah, I like it a lot. I feel at home here, or at least, as much here as anywhere else in North America."

"It's funny, though: Nowhere feels as much like home to me as Africa," he said. "When I got off the plane in Nairobi the second time, I felt more at home there than when I go to Long Island. I don't know what it is.

"If there is reincarnation, I must have spent several lifetimes there. Maybe that explains it."

HOME
TO THE DARK
CONTINENT

*No place feels as much like home
to me as Africa.*

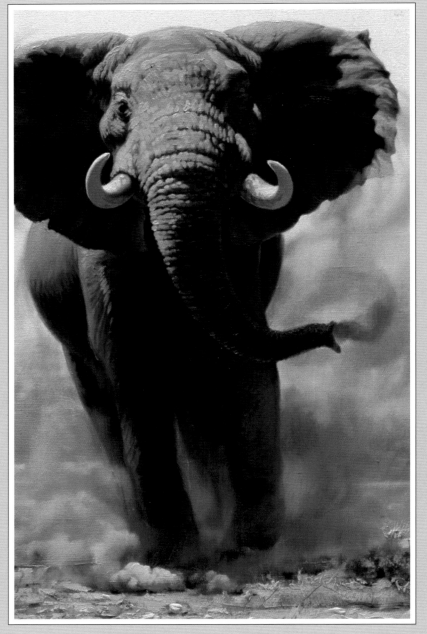

Detail of *The Charging Elephant* • Oil on canvas • 30 x 40 • Print: 1975

"No place," Guy Coheleach once told me, "feels as much like home to me as Africa does.

"When I got off the plane in Nairobi the second time, I felt more at home than when I go to Long Island. There was this tremendous feeling I had — all the pressure, all the nonsense, just disappeared."

In Africa, Coheleach's life changes. He can go to bed at 3:00 A.M., be up before dawn, and not even need to rest during the day. More than just invigoration, Africa makes him feel like a different person.

"If there is reincarnation, I must have spent a number of lifetimes there," he says.

he has made, but a reasonable estimate would be "50 or 55, somewhere in there." They have been as short as three days and as long as three weeks, and have included the Republic of South Africa, Zimbabwe, Namibia and Zambia, as well as East Africa.

Naturally, he lost no time in translating the vivid images in his mind into equally vivid images on canvas, and through the late 1960s, Coheleach began to specialize in African animals. He had been at it for several years, and was gaining quite a reputation, when an incident occurred that quite literally changed his art, after almost ending his life.

In 1972, Coheleach painted two works to be donated to the World

The affinity Coheleach feels for the continent of Africa is mutual, at least if what Africa has given back to him is a fair indication. More than any other geographical location, Coheleach's name is associated with painting African animals, especially the big cats and, to a lesser extent, the elephant.

Coheleach made his first visit to Africa in 1966. He won the novice division title in the Winchester National Trap and Skeet Championship, and the prize included a trip to London, England.

"After London, I bought a ticket for Nairobi and just kept on going..."

Once in East Africa, he visited game parks in Kenya, Tanzania and Uganda, and ignited an enduring love affair. Since that time, he has literally lost count of the number of trips — pilgrimages, really — that

Wildlife Fund auction in Palm Beach, Florida. A lady who was both an art lover and an elephant hunter made a special trip to the auction with the intention of bidding on the elephant. Upon seeing the actual painting, however, she turned it down because, as a hunter of elephants, she recognized a game park animal when she saw one. And, as a hunter, she wanted a portrait of an animal with fire in his eyes.

Taken aback by this assessment of his work, Coheleach headed for Zambia determined to see exactly what she meant. In the Amwell Press anthology *Hunting the African Elephant*, Coheleach describes the encounter in a piece entitled *Fatal Encounter — Almost!*

"I had been informed by an acquaintance at the bar while in Lusaka that if you step into the charge of an angry elephant, it will stop or

turn because 99 per cent of the time they are bluffing," Coheleach wrote. "He and I went down to the river to a new game park whose rules were not very important to the insurgents (returning to Zambia from incursions into then-Rhodesia, and given to shooting up the game parks for laughs)."

Frequent encounters with trigger-happy terrorists had turned these animals into anything but docile game park pets. With luck, Coheleach and his friend hoped to test their theory on animals with serious social problems. Along the river, they found two elephants browsing. Coheleach approached one from behind. Hearing him, the elephant wheeled, his ears went out, his trunk went up, and he "shook the whole damned riverbed with that blasting roar which everyone calls a trumpet.

"I must admit even now that the sense of exhilaration which surged through me was incredible," Coheleach wrote. "That invincible feeling that moves immature machos surged through me.

"I remember throwing my brand-new movie camera up in the air in sheer elation."

That elephant made one more bluffing charge before it departed downriver in search of more congenial company. Now feeling rather expert on irritated pachyderms, Coheleach turned to the second elephant, a monster whose sheer size made his three-foot tusks look like twigs, and who proceeded to put on "quite a performance." As his companion recorded the events on 16-mm film, Coheleach tried to provoke one last mock charge with the aid of a "good sized rock."

At which point, the elephant had had enough.

Coheleach: " 'Get the hell out of there!' my mentor screamed as I finally realized the elephant was having no more of my nonsense. His movie footage stopped at about this moment. Mine kept going until, with intermittent pans of the ground and sky, the last frame was filled by just elephant tusk.

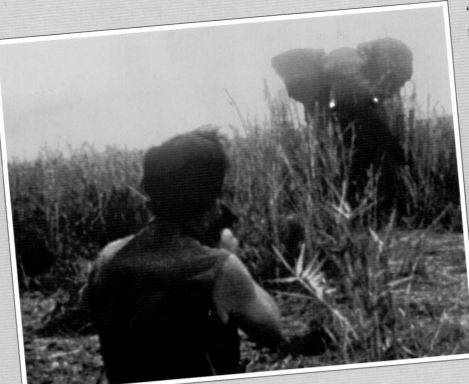

"I threw my camera at his face and ran like hell. Heading towards the riverbank, I turned to see where the monster had stopped, only to find his outstretched trunk about three feet from my head. At this moment, I knew it was all over..."

It would have been, too, but for a couple of strange strokes of luck.

"My physical body remembers pain in my chest, legs and back. I remember lying on the ground with sand in my mouth and face, and a tsetse fly buzzing in my nose. I remember looking up and seeing the whole sky filled with elephant. I remember being hit twice on the head with what must have been his tusks. I remember hearing a shot and having those huge feet landing between my chest and knee; between my chin and shoulder and brushing my back. I remember hearing another shot and more feet brushing me, somehow never landing on me. The elephant finally stumbled off to feed a half hour later with the rest of the herd. I remember Eric yelling for me to get up, but I couldn't."

Eric was Eric Balsam, the head of the game park. Hearing trumpeting from the river, and already suspicious of the intentions of Coheleach and his friend, he had come down to investigate. What he found was a huge elephant in hot pursuit of a small human. The shots Coheleach heard were Balsam firing to drive the animal away.

The strokes of luck that saved Coheleach were, first, that the elephant was too tall to allow him to drive one of his relatively short tusks into Coheleach's prostrate form. So, he decided to dispatch his tormentor by kneeling on him; second, Balsam managed to put a bullet into the elephant's honeycomb skull above the brain, dissuading him from punishing Coheleach any further, but not causing him to fall dead on the artist.

Coheleach's accounts of the incident, both written and oral, are laced with words like idiot, nitwit, imbecile and fool. Few involved or uninvolved, would disagree. The elephant, for instance, left no doubt about his views on the matter. On a painting of a greater kudu that Coheleach later created for Eric Balsam as a gesture of thanks, he wrote, "to Eric Balsam, to whom this intrepid but foolish wildlife artist owes his life."

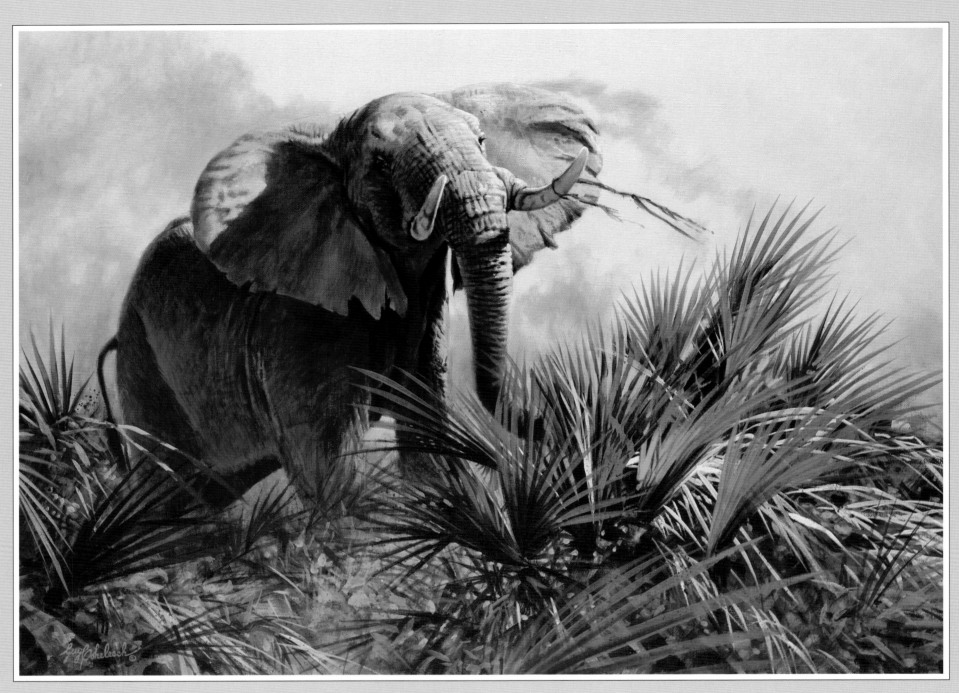

The Last Ivory Hunt (Elephant) • Oil on canvas • 22 x 30 • Print: 1986

Since his brush with eternity at the end of an elephant's tusk in late 1972, Coheleach has become a connoisseur of pachyderm moods and mannerisms. Appearances, perhaps, to the contrary, this African bull elephant, under the sun in open country, is not charging.

He's just extremely irritated. He's tossing some dust around and saying, "All right, you guys, get outta here." Which I would now do. Immediately. Charging, he'd be coming right at you.

Today, viewing the stark footage on a VCR in Coheleach's peaceful studio in darkest New Jersey, without sound, without narration, the black and white footage has the surreal violence of a nightmare. Watching it once, twice, the images never becoming quite defined, seeing now a tusk, now perhaps the outline of an ear, until blackness overwhelms the screen, it is easy to see why Coheleach does not like to watch it himself, and why for years afterwards even hearing the word *elephant* induced trembling terror.

But, as he wryly points out, he had now seen an angry elephant, and his approach to life, to animals, and to art would never be quite the same.

From that time on, Guy Coheleach's frequent trips to Africa took on a new flavor. He began to eschew parks, with their unnaturally tame and tolerant animals, in favor of going out with professional hunters who were engaged in animal control operations of various kinds. He saw animals killing, and animals being killed. He became a connoisseur of the predator/prey relationship, and translated his hard-won knowledge into dozens of paintings that redefined wildlife art as well as the art of Guy Coheleach himself.

"An artist today could go into a library and never be outside the city, and see pictures of wild animals, and paint them, and paint them to the degree they'd be accepted," Coheleach says. "It could be done.

"He'd never really know the soul of the animal, not having witnessed it, not having hunted it, not having been chased by it, not having seen it fighting with others or feeding its young. Photographs just don't do it.

"As an artist, you can paint the predator/prey relationship a great deal better if you hunt, if you've had something chasing you..."

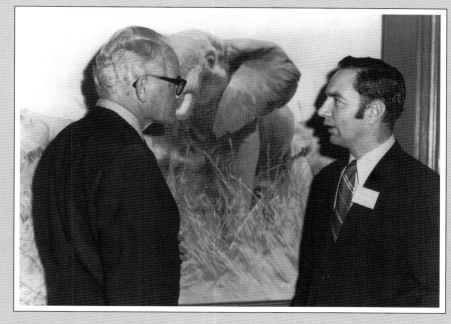

Senator Barry Goldwater and Guy Coheleach in front of Elephant painting he donated to the World Wildlife Fund 1972.

So in the interests of artistic integrity, Coheleach has been chased. He has also been charged, chewed, swatted, ambushed, stomped, almost tusked and generally subjected to attempted mayhem by a variety of large beasts in varying degrees of annoyance — with his proximity, with the company he kept, or with him personally.

One time, he was riding in the back of a safari car, fleeing from an elephant who had grown tired of being photographed. Pat Carr-Hartley of Kasani, Botswana, was at the wheel, and as they jolted up a bank they hit a tree root, jarring the tree and shaking loose a black mamba, one of the fastest, deadliest, and most short-tempered snakes in all of Africa.

"He must have been 12 feet long," said Coheleach. "The thing lands in the back, part of it in my lap, on my bare leg, and he starts slashing and biting the padded armrest beside me.

"It all could not have taken more than two or three seconds, but it's frozen in my mind, in slow motion — him biting and trying to chew that thing, and seeing the venom flowing, then lifting up and slashing around and biting the backrest.

"Now, I've dealt with poisonous snakes. I've milked rattlesnakes and cobras a thousand times, but I know what mambas are, how aggressive they are, and how much venom they can put into you — probably a hundred times more than it takes to kill you.

"If they bite you in the arm, the safest thing you can do is cut your arm off."

The mamba finally slithered down the side of the safari car, with a little assistance from an exceedingly careful Guy Coheleach.

"I'll tell you, I was terrified. And Pat didn't even know what was going on until the mamba was taking off. Now that was hairy!"

By such experiences do wildlife artists gain an appreciation of their subjects, and Coheleach is dedicated to realism, not to painting every hair and feather, but to ensuring that each animal has the right glint in his eye. A direct result of his near-fatal encounter with the Zambian elephant was *Charging Elephant*. Painted in 1974, the elephant is transplanted from the Zambian riverbank to the dry East African plain, and his tusks are a little larger. But the look in his eye is unmistakable. That is one upset elephant — an animal no hunter would mistake for an effete boulevardier of the game parks.

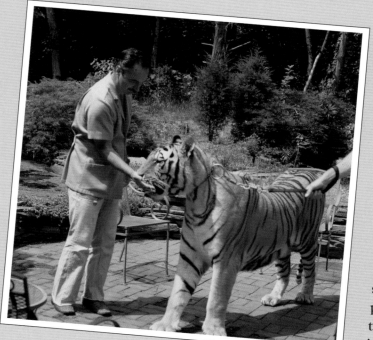

The big cats are Coheleach's particular love, and photographs abound of Coheleach with a young leopard draped around his shoulders like a shawl. His daughter, Coleen, tells of bringing a couple of friends home for a swim in the pool on Long Island, only to find a 650-pound Siberian tiger lazily enjoying the cool water, swimming in lonely splendor.

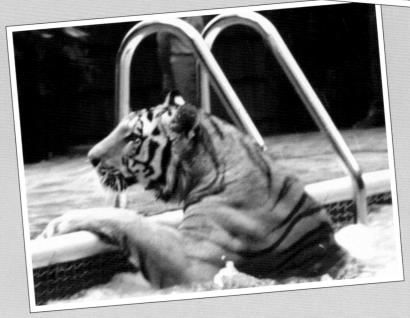

"Better wait until Ruffles has had enough swimming," Coheleach advised, and the girls needed no second hint.

His adoration of the big cats manifests itself in many ways. At one point in the 1970's, he commissioned the great Italian shotgun makers, Abbiatico & Salvinelli, to make him a set of shotguns, his own works of art reproduced on the frames and lock plates in their incomparable bulino engraving. Prominent among the works chosen (although

inappropriate, perhaps, for bird guns) were the big cats. As well, Coheleach's personal stationery bears a portrait of a Siberian tiger.

"Given the choice, I could paint predators the rest of my life," he told me. "Tigers, eagles, leopards. Dangerous creatures. I love them."

Indeed, Coheleach's reputation as an artist is based to a great degree on his work with predators — not just with his individual paintings of lions, leopards, tigers, and the other big cats, but with a major project which is unique in the history of wildlife art.

In 1982, he published, in collaboration with Nancy A. Neff, the remarkable book *The Big Cats: The Paintings of Guy Coheleach.* It is an interweaving of science and art that may well go down as the best book on the large feline predators ever done, anywhere. More than just another coffee table compendium of pretty paintings, *The Big Cats* is a serious textbook on the large feline predators: the lion, the tiger, the jaguar, the puma, the cheetah and the leopard, including the snow and clouded varieties.

"I wanted to produce a serious academic work," Coheleach says. "I wanted it to be a textbook for scientists and students, as well as lovers of big cats and admirers of wildlife art. I wanted it to be a lasting tribute to the big cats."

As he tells it, he called up a friend at a major museum in New York and asked who the resident expert was.

"He told me he had a gal working out in the back who knew more about the big cats than anybody."

The *gal* was Nancy A. Neff. She agreed to collaborate — on condition Coheleach did not refer to her as a *little gal*.

The book they produced is a large format, 240-page volume, with chapters covering every aspect of the natural history of big cats, from their evolution and place in the development of the order

carnivora, to the biology of modern cats, to the genetics of cat coloration, comparisons of cat's eyes with those of other meat-eaters, the mechanism of their retractable claws, and an explanation of why some purr and others roar.

The work is exhaustive. It was also exhausting. Everyone involved, Coheleach says — the author, the book designer, the specialists who prepared the intricate and detailed technical figure illustrations — put forth a superhuman effort, and that effort shows.

The final product, when she saw it, brought tears to the eyes of Nancy A. Neff; it brought joy to the hearts of the publishers, Harry N. Abrams, Inc., and acclaim to everyone involved in the project when it was made a Book-of-the-Month Club selection in 1982.

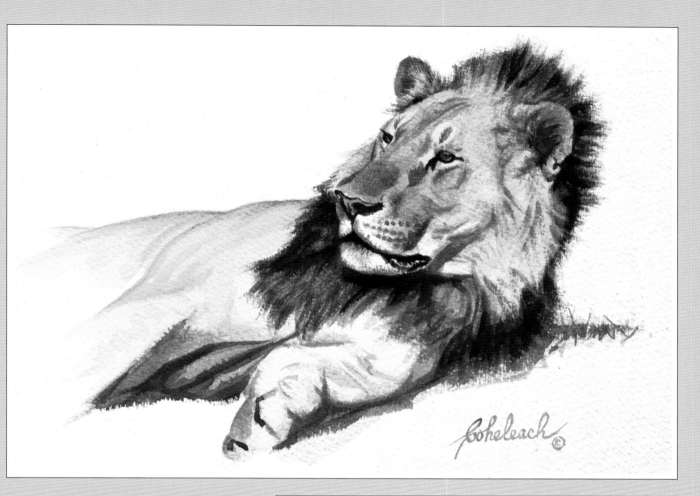

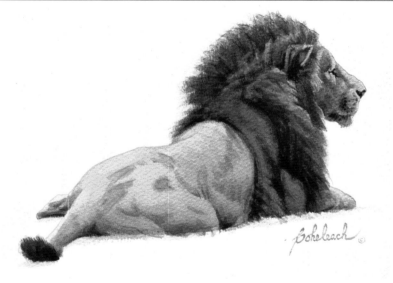

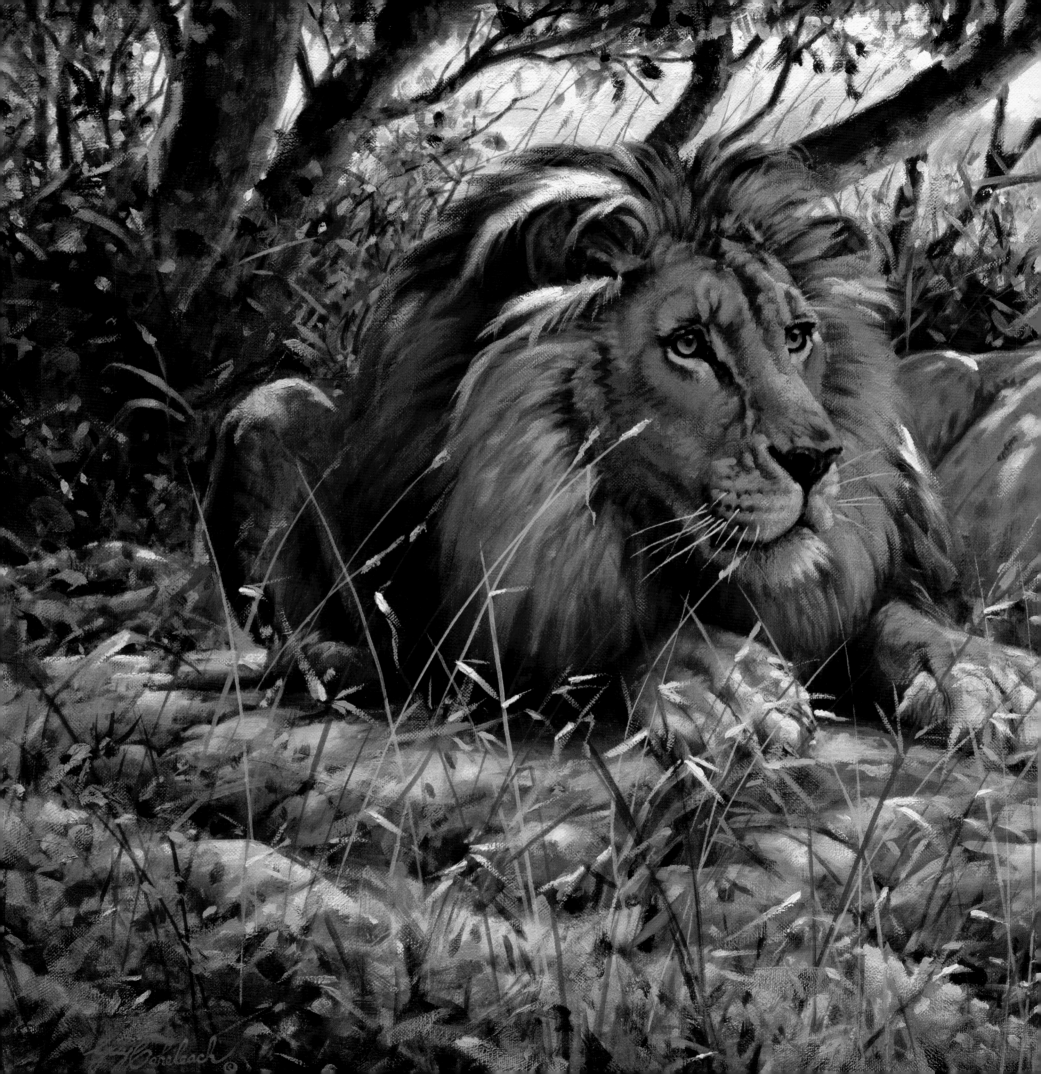

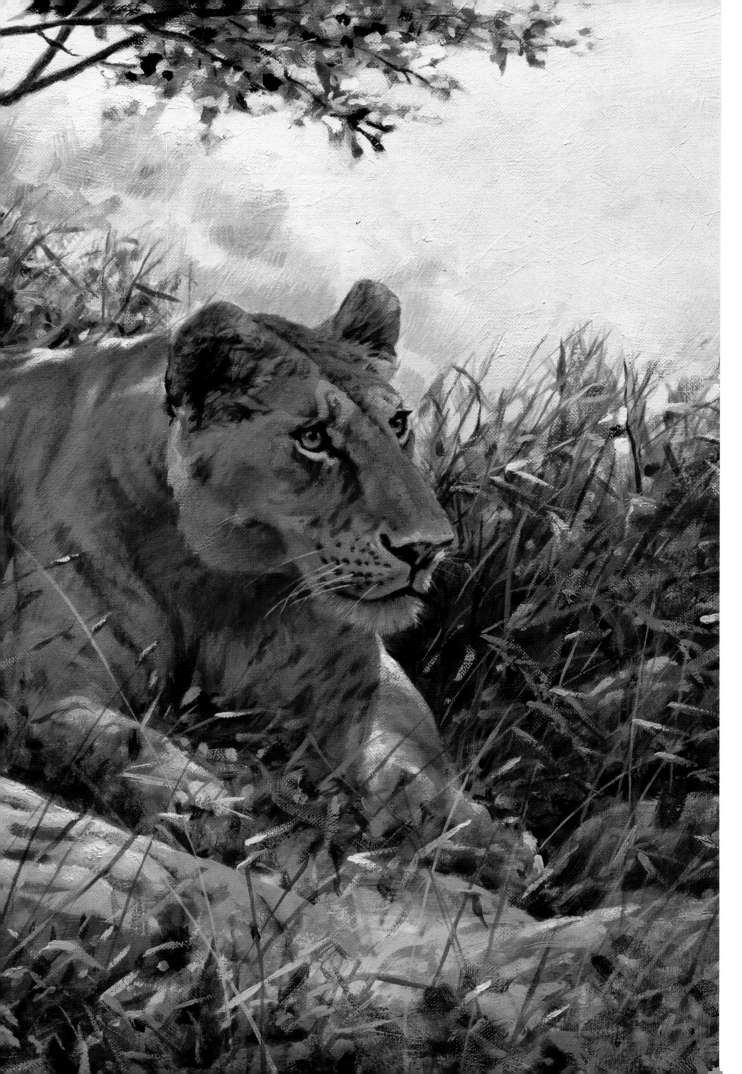

Distraction (Lions) • Oil on canvas
15 x 30 • 1993

Art is not always dead serious
business, and Coheleach loves to be
playful in both his titles and his subject
matter. This pair of lions was
interrupted in the midst of lovemaking
by something which might prove to be
lunch. They are not sure yet, but they
are... distracted.

*That was a great, fun painting to do. I
painted it because I wanted to, I
painted with paint, and I didn't care
whether it was printed or even whether
I sold the original. I just painted it
because I wanted to.*

Coheleach's illustrations — 154 in all, including sketches, pencil drawings and 59 color plates — represent possibly the finest assembly of work on the big cats ever done. By coincidence, it was about that time that Amwell Press decided to produce a five-volume series of anthologies on the African Big Five (Cape buffalo, elephant, lion, leopard and rhinoceros, in that order of publication) and approached Guy Coheleach to illustrate them.

As of 1993, three had been published (*Hunting the African Buffalo, Hunting the African Elephant and Hunting the African Lion*). The fourth, the leopard book, is in production. Each contains five color plates and dozens of sketches and pencil drawings; as well, Coheleach contributed a chapter to the first two, drawing on his considerable expertise on Cape buffalo and elephant.

He does not have the same enthusiasm for the work contained in the Amwell Series as he does for *The Big Cats*, but taken together they represent a unique side of Guy

Coheleach: a willingness to use his art to try to accomplish something new, something bigger, something more meaningful. In one, great art complements a fine scientific text; in the others, he helped blend great wildlife painting with literary achievement. Like Hemingway's publishing of *Death in the Afternoon* and *Green Hills of Africa,* sometimes the attempting of something that has never been achieved carries with it a cachet, win or lose, that cannot be achieved by anyone, no matter how successful, who never puts it on the line.

In all of these projects, a vital factor has been Coheleach's intimate, first-hand knowledge of wild animal behavior in their natural habitat, unfettered by bars, unhampered by fences, their instincts unrestrained by the arrival of dinner in a dish. This knowledge Guy Coheleach owes to Africa, because only in Africa does one have the opportunity to see, up close, animals behaving as all animals used to, before the advent of game parks and unnaturally protected environments.

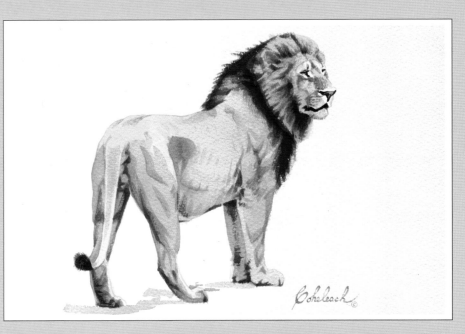

This knowledge is as precious and as hard-earned as his ability to paint, and he speaks frankly of its value to him as an artist. For example, he tells the story of painting a Cape buffalo. As he was adding the final touches, his house guest, Fred Bartlett, walked up behind him to watch. Bartlett is one of the best and most respected of the modern-day African professional hunters.

"He stood and watched as I finished touching up the eyes," Coheleach says, "and he told me 'You just can't paint a Cape buffalo better than that.'

"When I get a compliment like that from him, and he's a man who knows, it doesn't matter that 99 percent of the people who don't know might prefer some other artist's Cape buffalo."

Coheleach estimates one third of his effort goes into making each painting "that extra one percent better." That's one third of the painting time — it doesn't include his time spent in the bush seeing the animal first hand so that he knows what that extra one percent is. A direct result of the Zambian elephant incident, this passion for ultimate detail, for the agonizing exact way it is, sets Coheleach apart from most other wildlife artists, and has made him an expert on the difference between animals in a zoo, and animals in the wild.

"Take a zoo elephant: you can see where they've rubbed, where they've gotten fat and paunchy, just like a zoo cat. Well, actually, it's a lot harder to tell the difference between a cat that's on a good diet and a wild cat, compared to a zoo elephant on a good diet and a wild elephant..."

(This is a degree of arcane discernment that is beyond most observers. In fact, it is beyond many wildlife artists. It is certainly beyond me.)

He continues: "It's like zoo deer, you know? They just lose their fear, they lose that tension in the eyes, they lose that life force; it's...it's an electricity about them.

"You look into the eyes of a leopard in a zoo, and sure, you can get a lot out of them. But look into the eyes of a lion 30 feet away from you, when you're standing right in front of him with no rifle, and let me tell you, they look a lot different. They do."

Knowing there is a difference, knowing exactly what that difference is, and knowing how to paint that difference are three tough steps, and Coheleach does not believe he has mastered them yet. But he keeps working on it, and a big part of that work involved going back to Africa, year after year, to spend time in the field with brush, camera, or just his eyes, watching, watching, watching.

Coheleach's observations in Africa are not limited to the fauna. Over the past quarter century he has witnessed, first hand and close up, the changes that have ravaged various parts of the continent, at times endangering local game populations and even entire species. Some of these changes have been political, others due to war, famine and drought. By far the greatest, in terms of overall impact on the animals has been the devastating explosion of the human population which threatens to crowd out wildlife even in the parks and reserves that have been set aside for them.

"The population explosion all over the world is just wiping out habitat, and it's not just Africa," Coheleach says. "African nations need currency and elephants don't vote, farmers do."

Since independence in the early 1960s, the populations of Tanzania and Kenya, to give two examples, have roughly tripled (from nine million people each to about 27 million) and their birth rates are the highest in the world. The average Tanzanian woman has eight children. In the old days, only two might survive; today, the mortality rate has declined and a larger percentage of children survive, yet the birth rate continues at its previous level. The result

is a burgeoning human population, hungry for food, hungry for land. This has put tremendous pressure on governments to open more land for agriculture, including some which lies within national parks and preserves. Animals like elephants, which require vast areas in which to roam and which devastate the country if they are confined to a small area, have suffered especially.

"The first time I went into Amboseli (National Park, in Kenya) there was a little sign along this dirt road saying that you were going into the park. Nothing else. Today, when you go to Amboseli you run a gauntlet of beggars and merchants trying to sell you souvenirs. There are villages at every entrance to the park."

There is growing evidence, however, that governments, ever hungry for foreign currency, are coming to realize that they stand to make much more money from the wild animals, especially from hunting which brings in currency, provides employment, and also provides meat for local populations. So, while the overall trend may not be encouraging, there are some hopeful signs.

"Some of them are now finding out that elephants bring in a lot more money than cabbages. I think they are seeing the value of wildlife, especially in the hunting safaris," Coheleach observes.

"When I went over there first, the old colonials, the professional hunters, complained about overpopulation, how it was ruining the country and destroying the animals. They were comparing 1966 to 1946. Well, I'm comparing 1993 to 1966 and I now see it the way they did then. I see all the changes for the worse. But people going there today, for the first time, won't see it that way.

"Anybody going over there now for the first time is going to be absolutely enthralled seeing an elephant or a lion close up, and there are still some spectacular wildlife sights to see, things you can't see anywhere else on earth."

In 1992, the publisher of *Wildlife Art News*, Bob Koenke, organized a special, promotional tour of southern African game parks. Five artists from the United States accompanied Koenke on the tour — Bob Kuhn, Lindsay Scott, Paul Bosman, Mort Solberg and Guy Coheleach. In return, the artists would provide paintings and sketches which would be reproduced and sold, with the proceeds going to various conservation funds.

The three-week sojourn took them to South Africa, beginning with the fabulous Kruger National Park, then to Botswana's Chobe and Okavango Delta, and Namibia's Skeleton Coast, with stops at a wide variety of public and private game areas along the way. "It was," Coheleach said, "the most productive and fascinating trip I've ever had there, and I've been to Africa more than 50 times."

It was particularly productive in terms of studying the predator/prey relationship.

"At some of the private game areas outside Kruger, we saw leopard killing warthog, leopard killing a kudu, a cheetah killing an impala. We saw things you would not believe. At one point, we literally hunted with lions," Coheleach said.

"In this one game park, the animals are so used to the vehicles that the antelopes completely accept them, and the lions use the vehicles as moving blinds to screen them from the antelope as they stalk them.

"The lions let us go ahead while they just walked along behind us, using the vehicles as shields. They were so close I could have touched this one lioness with my hand if I'd leaned out — but of course I didn't do that.

"It was awesome. At one point, I remember this one lioness looking over and making eye contact with me. It was an extraordinary experience, because here was this lioness, maybe 10 or 15 feet away at the most, looking right at me. If she liked eating human beings, we were there for the taking!"

This was experiencing the predator/prey relationship in spades — hunting with the lions, but potentially standing in for the prey, if the antelopes escaped. It was the kind of field experience for which, in Coheleach's view, there is absolutely no substitute.

"The importance of doing any field work cannot be exaggerated. You can't do a painting of the predator/prey relationship — not a good one, anyway — unless you have seen animals hunting other animals, up close.

"It helps if you have been hunted, if you've had a wounded buffalo coming after you, or if you come up over a knoll and there's a pride of lions, with about 20 cubs and who knows how many adults — "

"— too many! —"

"Absolutely! That's the truth! And you stop and start to back up, moving slowly. You know that all it requires is one lioness that doesn't like the look of you, or one young male that didn't get enough to eat off that last zebra, and you are just two or three bounds away from them, and if they feel in the least threatened...

"Hey, that's Africa. That's my Africa.

"That's home."

REPAYING AN ANCIENT DEBT

…it was just Coheleach being Coheleach: a generous man with his time, his money, and the product of his talent.

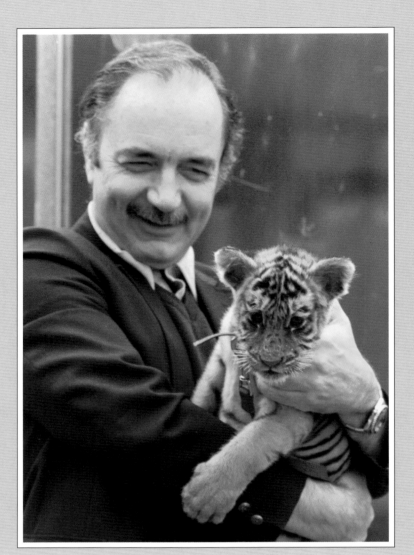

Bob Koenke, the publisher of *Wildlife Art News*, remembers getting off the plane in Johannesburg on his 1992 tour of southern Africa with Coheleach, Kuhn, Solberg, Bosman and Scott.

"Our luggage was coming down the conveyor belt and we pulled the bags off one by one. Guy was gathering in his bags, and then a bunch of cartons started coming down, all with his name on them. 'What are these?' I wondered."

"Prints," Coheleach replied. "I brought a few to give away to people. Thought they might be able to raise a little money, selling them..."

A few prints; a little money. In actual fact, he gave people he dealt with on the tour a total of $10,000 worth of Coheleach African prints — gratis, no strings attached. This was not part of the deal, it was just Coheleach being Coheleach: a generous man with his time, his money, and the product of his talent.

Over the years, Guy Coheleach has donated art work for conservation causes amounting, at a conservative estimate, to several million dollars. But wildlife conservation is not his only concern, by any means. He is also involved with professional organizations such as The Society of Animal Artists.

The very first time I met Guy Coheleach, he was in Philadelphia on behalf of that Society, arranging the location for its annual exhibition. He had driven down from Bernardsville for the meeting, a two-hour drive each way for a one-hour conference. For a man as chronically busy as Coheleach is (trying to arrange even a one-hour interview is a complex undertaking), such a sacrifice of precious time is a contribution more valuable than money or art prints.

"Maybe I do spend too much time on this kind of stuff when I should be working, but I guess it's all part of giving something back," he told me at the time.

"That's something that concerns me more and more as I get older. Sometimes I think that's really the only thing there is — leaving things a little better than you found them.

"I'll tell you a story. You know I paint a lot of baby animals. Don Eckelberry, who is a great artist and a really dear friend of mine used to kid me a lot. He'd say 'There goes Coheleach, painting the cute little animals and laughing all the way to the bank.' Don't I wish! Don used to ask me when I was going to stop painting that stuff and produce some real art. So I decided that was what I was going to do — stop painting baby animal pictures and turn out real art.

"I swear it wasn't two days later I got a letter in the mail from a nurse in Wisconsin. She said she was nursing a little girl who was 'seriously ill,' which in nurse's parlance means terminally ill. In all the time she'd been nursing this little girl, she'd never seen her smile. I'd donated a lot of prints to this hospital — basically, I'll donate as many as they'll have framed and hung — and they had hung a print of a baby polar bear in this little girl's room.

"The next day, when the nurse went into the room, the little girl was sitting there looking at the picture, smiling for the first time.

"I thought to myself, come on, how can I stop painting pictures that will do that? That's what it's all about: producing something that will make people feel a little better."

My first visit with Coheleach was dictated by his frantic schedule, a day and a bit jammed in between the meeting in Philadelphia for the Society of Animal Artists, and a trip to Cincinnati for a fundraiser. Coheleach had painted *Angel's Chase*, an imaginary rendering of the Cincinnati Zoo's star cheetah Angel, in pursuit of an antelope as she might have been on the Serengeti Plain. The painting was being auctioned to raise money for the zoo. Naturally, Coheleach had to be there, and we were up at five and on our way to Newark Airport before dawn.

Coheleach's contribution to conservation has not gone unrecognized, officially. In 1976, he was awarded the title *Conservationist of the Year* by the African Safari Club of Washington, and the list of beneficiaries of Coheleach's dedication include the National Wildlife Federation, National Audubon Society, Safari Club International, The Fund for Animals, Inc. (Coheleach is one of the few people in the world on speaking terms with both Cleveland Amory and the hunting elite), Holy Land Conservation Fund, National Foundation for Conservation and Environmental Officers, assorted zoos, universities, and Game Conservation International (GameCoin).

While Coheleach is generous, he is also hard-headed and realistic. He will give — but he makes very sure it's for a good cause.

One of his pet grievances over the years is the fact that artists who donate their work to raise money for conservation or other causes do not receive full benefit from it in terms of taxes. With Coheleach, the conversation can swing from altruistic idealism to gritty reality (even resentment) in a twinkling, especially when it comes to the question of taxes and contributions.

"I have no idea how much I have donated over the years," he says, "although it is well into the millions by now in terms of the money raised." In 1969, for example, he donated prints that helped recruit 13,000 new members for the Florida Audubon Society; in 1972, he donated original paintings to various conservation groups that sold, at auction, for $283,000.

Most people assume that if he donated this, then he must be getting a generous tax write-off, and such is not the case.

"As an artist, if I do a painting and donate it to an organization, all I am allowed to deduct is the cost of the canvas and the paint — nothing more. If it sells for $10,000 at auction, I am still allowed to deduct only a few dollars for the cost of the materials.

"Now, look at the guy who bought that painting. If he's in a 70 per cent tax bracket, he can deduct the cost as a charitable donation, which means he pays only $3,000. The way the laws were back then, he could hold onto the painting for a year, value it at $20,000, then donate it to a university or museum. That was deductible, too, so he gains another $14,000 he doesn't have to pay in taxes. And if he donated it, gave them title on condition he be allowed to borrow it for the rest of his life, he ends up with the painting and an actual cash profit of $11,000 in just two years.

"That really irritated me. It really did. The law's changed now, thanks at least partly to me, because I complained about it to anyone and everyone, every time I got on television.

"And what did I get? The year those paintings sold for $283,000, in hard cash, I was allowed to deduct the cost of the canvas and the paint.

"Now, had I been run over by a truck the day before those paintings were sold, my family would have been immediately liable for 70 per cent of the full commercial value of the paintings.

"Is that fair? I get taxed on full value, but I can't deduct full value if I donate one. That really burns me! I wouldn't mind so much, if they were at least consistent…"

Over the years, Coheleach has fought the system, trying to get a fair deal for artists, so far with limited success. But he keeps trying. The injustice of it rankles, and he keeps trying.

Coheleach's involvement in conservation grew simultaneously with his fascination with Africa.

"You can't be interested in the outdoors without caring about it, and if you care about it you want to save it from harm," he says.

Over the years, however, his approach to contributions to good causes — both those related to conservation and others — has changed. If it is a question of parting with actual cash, he reserves it for groups who cannot make use of a donation of art work.

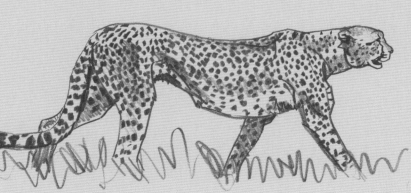

Conservation groups he knows he can help enormously by contributing paintings and prints which they can then sell to raise money.

There is also a healthy element of cynicism because, as interest in conservation has grown across the country and around the world, new organizations have popped up like mushrooms after a summer rain, and many, as he says, are little more than front organizations for Joe Professional Student who wants to stay a student all his life.

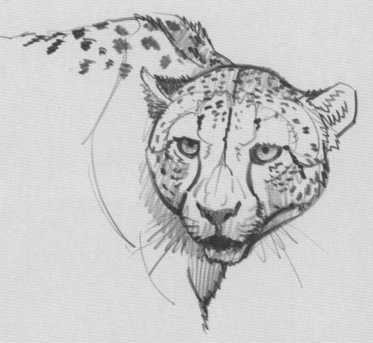

"I'm very cynical about a lot of them," he told me. "I know for a fact that there are two or three conservation groups I have donated to where the money was completely abused, where it went purely for travel expenses for the executives. I'm careful now to make sure the money they raise with my help will go to do some actual good."

As conservation organizations have multiplied, pressure has increased dramatically on artists like Guy Coheleach, Robert Bateman and other big names to contribute their time and work. In fact, it is expected that they will contribute on the assumption that wildlife artists have a special responsibility to protect nature. As the demands have grown, artists like Coheleach have found themselves in an uncomfortable position: they want to help, but they want to make sure the money is properly used.

Coheleach's reaction is nothing if not realistic: He continues to donate, but in the case of an original painting for auction he does so on a share-the-wealth arrangement. He makes some money, the organization makes some money, and even if they waste their share, his work will not have been totally squandered.

When it comes to charities and organizations that help people, he is less cynical, but no less careful. In fact, he will go to great lengths to ensure they are legitimate; once convinced, however, he will go to equally great lengths to help.

"There is an ex-nun who took over an abandoned factory building and made a school out of it, right in the middle of Newark, in the middle of the ghetto. She has these kids coming to school, and there is competition to get into that school because of the education they get. All she gets from the city is some security. But she educates these kids for about $820 (1992) a year, per student.

"It costs the State of New Jersey an average of something like $3500 a year, per student. She's doing this right in the ghetto, and she has triple the college entrance of the average school in the state.

"These are underprivileged kids living right in the middle of the ghetto.

"So I do my homework as far as causes like that are concerned, but when it comes to conservation groups, you have to be practical..."

While some believe wildlife artists as a group have a special responsibility to help conservation organizations, Coheleach does not agree.

"No more than any other human being, we don't. You can't go through life and just take, you have to give back something, but that applies to everyone, not just wildlife artists."

Overall, when it comes to assessing the impact of his contributions, Coheleach has a mixed outlook.

"Well, 1993 is a lot different than 1903, and 2093 is going to be a heck of alot different than 1993. The people born in 2093 are going to be fighting the same fight, but on a different level. Not the level that we know.

"I'm hopeful to the degree that, if we do screw up badly enough, the first ones to go will be us, and then nature can do it again, the right way.

"Elephants and lions and tigers will go, but nature itself will survive. The insect world can survive just about anything we can dump on it, and evolution will just come back and do it all over again, without us."

Meanwhile, he continues to make the effort the same as he always has. Those efforts may bear fruit and they may not, but that is no excuse for not trying. And, as he says, he feels he has to give something back because, in the end, that may be all there is.

IN STYLE & OUT

I would like to be able to say… If you go into a museum and want to tell the Coheleachs', just look for the good paintings. That would be lovely. That's what I'm striving for.

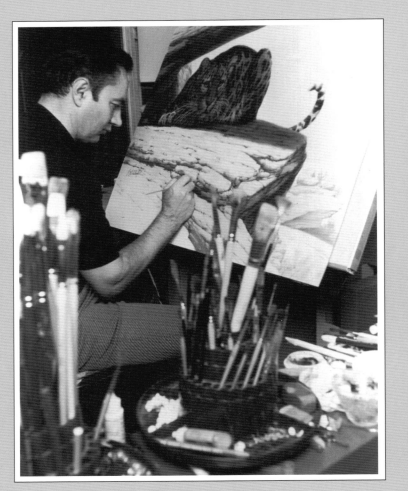

Guy painting in his studio 1973.

Coheleach reserves his greatest love for the Impressionists: Monet, Manet, Renoir. And his favorite artist of all is the man who might best be described as the impressionist of wildlife art, Bruno Liljefors.

"Liljefors had more economy, and said more in his work...and he just happened to choose Scandinavian wildlife, but oh God! When he did an eagle coming over, it was an eagle! You could tell those wings were made with a curve, and the air was sucking up the top of them and pushing up underneath them, and that was a great big heavy bird just floating down, coasting from the previous speed down, so he could pick off that rabbit...

"Or a peregrine! When he did a peregrine going through the marshes with the wind blowing and the leaves upside down so you see the silver part when the wind is blowing, you could feel the chill, the cold damp air!

"He was just marvelous.

"And the best part is, you couldn't take one stroke of paint out of his paintings without hurting the painting. And you couldn't make them a bit better by adding anything.

"Perfect economy: To me, that's the way to go."

Coheleach also admires Carl Rungius and Wilhelm Kuhnert. Kuhnert particularly he accords the title of "all-time greatest painter of African lions," and a Kuhnert original hangs above the Coheleach fireplace in Bernardsville, New Jersey, awarded the dominant position in the whole place.

Walter Cronkite and Guy Coheleach with his painting at Christie's, 1978.

Guy with Bwowae, his Masai guide in the Selous area of Tanzania, 1993.

One of the wolves from the movie
Dances with Wolves, 1991

1991 with Little Joe
(on the left)

Angel and *Angel's Chase*, 1987

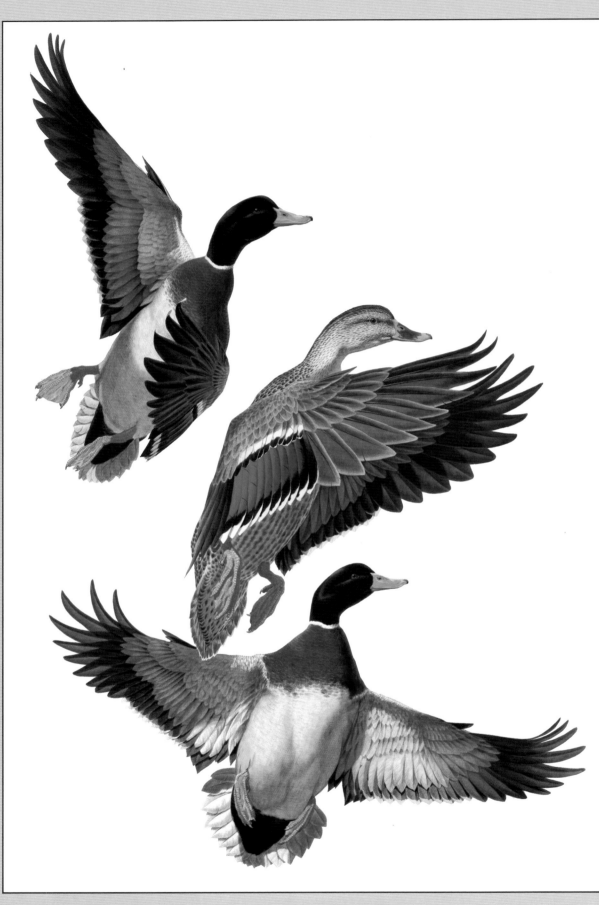

Mallards • Gouache on illustration board • 38 x 28 • Print: 1979

The painting, **Mallards***, was done immediately after* **Siberian Chase** *(p. 76).*

Siberian Chase *was very impressionistic, so I painted* **Mallards** *to show the wildlife art lovers that I had not lost my mind.*

The resulting painting is a classic, and is often used as an example of how a detailed bird painting should be done.

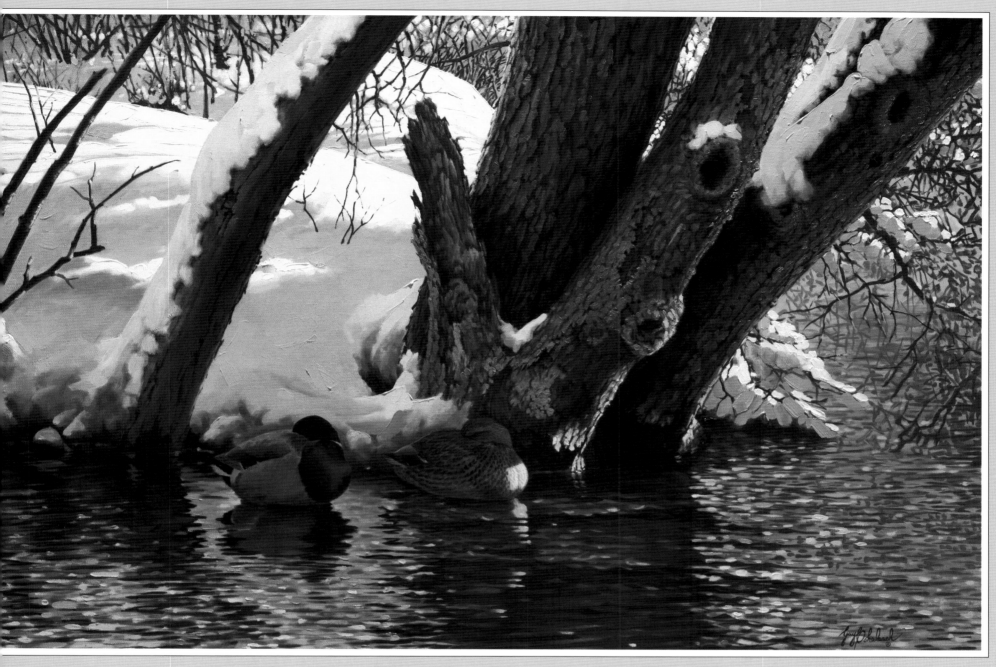

Brightwaters Creek • Oil on canvas • 36 x 72 • Print: 1985

One of Coheleach's most celebrated paintings, *Brightwaters Creek* has won a number of awards and now hangs in Leigh Yawkey Woodson Art Museum where, in 1983, he was honored as a *Master Artist* at the prestigious *Birds in Art* exhibition.

Oil (on linen canvas) is Coheleach's favorite medium, its only drawback being a rather lengthy drying time. Oil is perfect for the effect he wanted in *Brightwaters Creek* — water that shimmers and sparkles before the eye. The secret of the scintillating water, he says, is *vibration.*

Up close, you can see the strokes from my brush and palette knife. It looks like a palette covered with paint. But when you move back, all of the colors fall into place. Rather than blending them in and starting to look gray, the blue against the light brown really vibrates…it just looks much more alive from a distance.

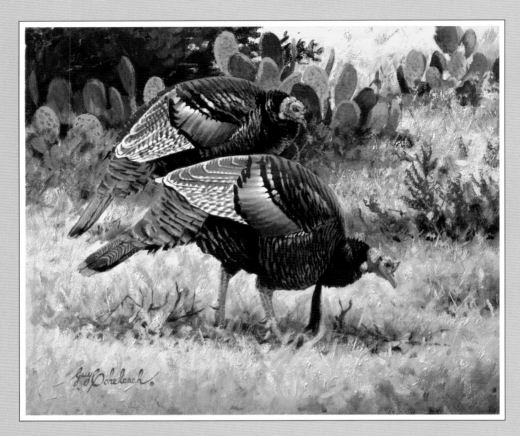

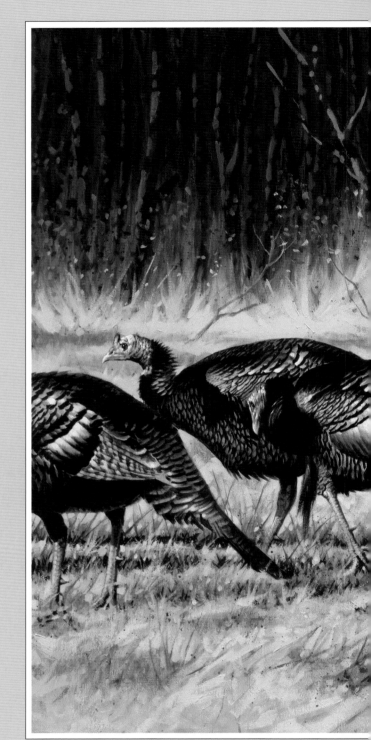

South Texas Turkeys (Wild Turkeys)
Oil on canvas • 9 x 12 (miniature) • 1985

Coheleach is very fond of painting wild turkeys, he says, because it is always a challenge to get the peculiar metallic appearance of the feathers.

This is a very common sight and I have seen it many, many times in South Texas. I like this painting because it is quite painterly — not necessarily impressionistic, but you can see the paint quite clearly.

Wild turkeys at Connequot State Park on Long Island were the models for *Gobblers.* Coheleach enjoys working large, and like so many of his big paintings, this three by six foot oil appears quite detailed in reduced form, yet the original is somewhat loose and painterly.

Three horizontal lines — trees in the background, birds in the center, and autumn grass in the foreground — serve as basic design elements. For the composition to work, the turkeys had to be in a line, which is why you see the one on the left cut off, leading the procession across the painting.

I love painting turkeys. In fact, someday I would like to do one in real detail, Audubonesque, just the turkey against a white background with every shade on every little feather.

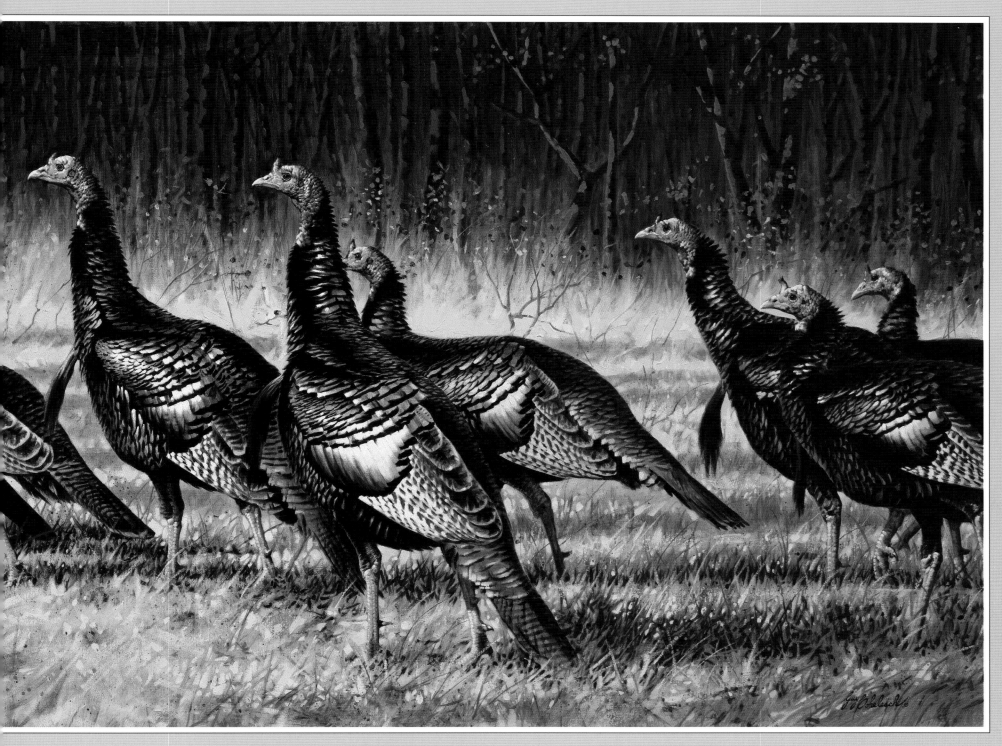

Gobblers (Wild Turkeys) • Oil on canvas • 36 x 72 • Print: 1988

Guy Coheleach grew up and began to pursue his art career during a very strange time in the history of art.

It was an age trying to cope with the legacy of Picasso and the Parisian schools of the 1920s and 1930s, and the post-war efforts of the modern, abstract, non-representational painters who, it seemed to the uninformed, were merely trying to outdo each other, making each new painting more outlandish and impenetrable than the last. Abstract, modern art was in the ascendancy from the time Guy Coheleach first took pencil in hand and began sketching birds in the margin of his school notebook. Even today, it is abstract, modern art that is accorded academic recognition, purchased and displayed in major galleries and museums, analyzed and fawned over by critics.

Throughout this period, representational art, including wildlife art, has been accorded little academic or critical acclaim. About all it enjoys is huge public popularity.

At Cooper Union, Coheleach was confronted with the art styles of the early 1950's: New York avant-garde, abstract — about as far away from wildlife realism as it is possible to get. Coheleach tried it, and while it didn't take, it left him with one tangible: An eye and a feel for design, and an understanding of how important design is in a painting regardless of subject or style.

"I still do a bit of that, abstract...not much since I left school, but some. I imagine I've tried just about every type of painting — representational, non-representational. You name it, I've tried it."

And, usually, done it well.

In her book *Wildlife Painting Techniques of the Modern Masters,* Susan Rayfield uses Coheleach as an example of both how to render feather tracts of birds of prey with "meticulous realism," and how to use a "loose, impressionistic style" to suggest motion in a painting of a bird of prey attacking a rabbit.

Later in the same book, Rayfield calls upon Coheleach's expertise in "expressing motion with design." Finally, she uses a 1979 Coheleach vignette of three mallards on a white background, a painting of "extraordinary detail," as an illustration of how to capture the iridescence of feathers.

"Meticulous realism and loose impressionism;" conveying motion one moment through impressionism, the next through design; and being acknowledged as the master of all.

Is this evidence of supreme versatility, a mastery of painting so great that it allows him to perform as a virtuoso in any style he chooses? Or is it evidence of a weakness — an inability to pick one style and make it his own, or to break away and do things that have never been done before?

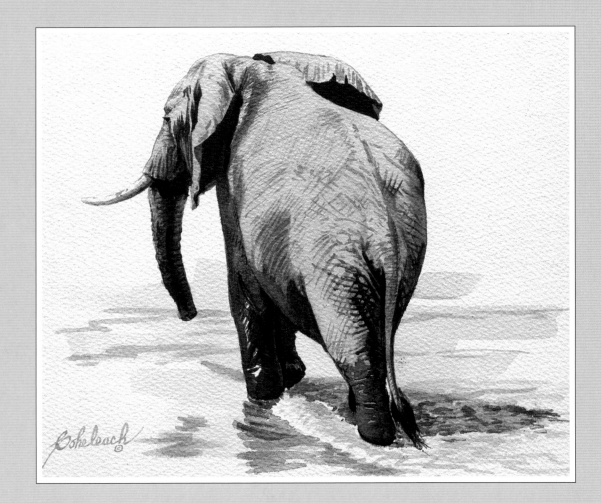

"God," Picasso once remarked, "is simply an artist like all the others. He invented the giraffe, the elephant, and the cat. But he hasn't got a style — he continues experimenting."

Guy Coheleach paints in oils and in watercolors, in gouache and acrylic. He begins each painting with a pencil drawing, and sometimes the pencil drawings are left to stand on their own, obeying Cezanne's dictum to treat everything in nature in terms of the sphere, the cylinder and the cone. Coheleach's spheres, cylinders and cones, black on white, move and mesh together like elements of a splendid machine, challenging the world with his draftsmanship.

In the studio beside the house in Bernardsville, there are two complete drawing tables, one for watercolors and one for oils, set one behind the other like pupils' desks in a primary school, each with its own clutter of brushes, paints, and paraphernalia.

Left to his own devices, Coheleach says he would probably do most of his painting in oils, with field sketches in watercolor. He is not left to his own devices because of that dominant factor in wildlife art today, the limited edition print. Coheleach was one of the first wildlife artists to sell limited edition prints, and even began with his own publishing company, Regency House, back in the 1970s. Since then, he has had contracts with several different publishers.

National Wild Turkey Federation presentation to President Bush.

Over the years, Coheleach's work has earned him a seemingly endless list of honors. He has been exhibited at the Corcoran Gallery of Art, the National Collection of Fine Arts in Washington, D.C., the American Museum of Natural History, the National Audubon Society, the White House Collection, and the Royal Ontario Museum.

Prints of a Coheleach bald eagle have been presented to visiting dignitaries as a gift from the United States, and he was one of the first western artists to exhibit in Peking after the second world war.

Guy Coheleach was awarded an honorary doctorate of arts degree from the College of William and Mary (1975), named *Master Artist* at the *Birds in Art* exhibition by the Leigh Yawkey Woodson Art Museum of Wisconsin (1983), and *Wildlife Artist of the Year* by the National Wildlife & Western Art Collectors Society (1985). Between 1979 and 1986, he was awarded the Society of Animal Artists *Award of Excellence* six times, with the judging (since 1982) done by curators and professors of fine art from the host city's museums and universities.

Still, the question of medium arises because of the peculiar demands of print making. By far the most popular medium for a painting which is to be reproduced is acrylic, a water-based opaque paint whose peculiar qualities enhance the appearance of the finished print.

"If I'm working for the print market, I will generally use acrylic. For a gallery or museum, I'll paint in oils. This doesn't mean an oil cannot be used to make a print, but if I know it is for a print I will generally do it in 30x40 size, in acrylic to get the detail," Coheleach says.

"Acrylic is water-based and dries faster, two factors that are helpful for prints. Because it dries faster, you can work over it quicker, and because it is water-based, you can get much finer brushstrokes (and hence the finer detail) which the print market demands."

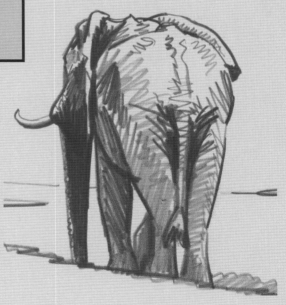

Jack and Barbara Nicklaus
with Guy in his studio, 1993.

1973 500 • Oil on canvas • 9 x 12

Johnny Rutherford passing A. J. Foyt in the Indianapolis 500

The Golden Bear at Amen Corner • Oil on canvas • 24 x 44 • Print: 1984

A Save at the Second (Muirfield Village Golf Club) • Oil on canvas
24 x 44 • Print: 1984

Sunshine Forever • Oil on canvas • 18 x 22

The Winner • Oil on canvas • 12 x 24

"My preference is oil because it is freer and it's more spontaneous and very sensuous working with oil paint on canvas. It's not the smell of the paint, it's the way the paint moves on the canvas. It's hard to describe, but oil is just much more fun!"

Acrylic does not do that for him. "It is," Coheleach says, "like painting with plastic. It has very high surface tension, which gives it an elastic quality, like painting with glue. Hills and valleys left by the brush tend to smooth out. Oil has no memory at all and no surface tension, so hills and valleys tend to stay the way they are applied. This gives acrylic a brighter look than oil, because without the hills and valleys there are no shadows thrown to mute the colors.

"When you paint with oil, the texture of the brush stays; with acrylic, it smooths itself out," he says.

"Something else about acrylic as compared with oil: Oil stays the same color when it dries as when you put it on. With acrylic, some dry darker and some dry lighter than when you put it on.

"Now that can get tricky! If you put a highlight on the forehead of an elephant and make it a lighter shade of grey, by the time it dries it has darkened to what you had originally, and disappears. The really good acrylic painters know how paint will change, and make allowances for it. I can't do that. I just keep trying things until it comes out right. That's another advantage of the fast drying time — when you work by trial and error, as I do, it speeds up the process."

Since childhood, Coheleach has worked in pencil and watercolor, and he retains an immense fondness for both although few of his pencil sketches or watercolors end up as finished *easel-style* paintings. If he is illustrating a book, such as **The Big Cats** or the Amwell Press **Big Five** series, he will augment his oil or acrylic paintings with both pencil sketches and studies, or vignettes, in

watercolor. The effect can be electrifying, capturing the essence of an animal in a few deft strokes to accompany a more in-depth study of its appearance and characteristics.

Coheleach particularly loves to do field sketches in pure watercolor ("the little dye tablets like we used in school, but much nicer") where the paint is transparent and the white is provided by the paper.

"Watercolor is a wonderful medium for making field sketches, because it is very portable and very spontaneous! It is so fresh all the time," he says. "The sketches may look clumsy and simple, but they carry incredible amounts of memory information. You block in what is important in a scene and leave out what is not. I can look at one and remember the smells and the sounds that I heard as I was doing those strokes on the paper.

"This memory association is very important in capturing a scene. For instance, there was a time when I could look at a painting and tell you every bit of music I was listening to when I worked on it!

"To me, the beauty of watercolor is the little spontaneous vignettes, an owl's head, a buffalo head. They look rough and loose, but they're really very clean and pure. I like them very much. I get a big kick out of doing them and out of looking at them — when they work."

When Coheleach does a finished easel painting, it is usually oil or acrylic. He has sold watercolors, but he does not consider himself a watercolorist in the sense that Winslow Homer was.

"That is a different realm entirely. Watercolors are easy — at least I think they are — but turning a watercolor into a completed painting is very difficult for me."

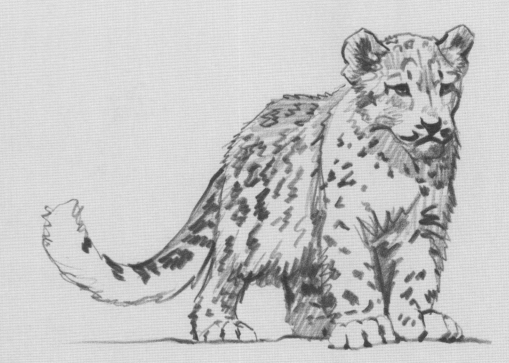

In spite of the critical acclaim he receives, in spite of the popularity of his paintings and prints, in spite of the admiration of other painters, there remains the nagging question of the Coheleach style — a question that seems to bother everyone except Coheleach himself.

He will switch styles, he says, from very tight and detailed to very loose and impressionistic "to keep from becoming bored." In the process, what he also does, however, is keep his work from becoming unmistakably his own, recognizable as a Coheleach if you wanted to pick one out in a crowd of good paintings. As with most things in his life, he approaches the question pragmatically.

"I take it a day at a time. I don't take it too seriously or feel that I've got to come up with the consummate Coheleach style. I don't have any grand plan to do that. I have enough of a struggle with each painting, trying to get it just right, whether it's a watercolor, or an acrylic or an oil. If a style is going to emerge, it's going to do so all by itself, without my help. At least, without my conscious help.

"I'm certainly not trying to develop anything, because I'd have no idea what direction to go. When I sit down to do a piece, I just want it to have zing and pizzazz. Whether it's impressionistic and spontaneous, or whether it is very tightly controlled and detailed and worked over, I still like it to look alive and wild.

"So if there is a style showing — well, I've had a lot of people say they can tell my work no matter what it is. I don't know how they can, because I certainly can't.

"If there is a Coheleach style at all, I'm not aware of it. You can tell a Bateman, you can tell a Kuhn, but I don't see how anyone could tell a Coheleach. I wouldn't even know what to look for.

"I would like to be able to say, that if you go into a museum and want to tell the Coheleachs', just look for the good paintings.

"That would be lovely. That's what I'm striving for."

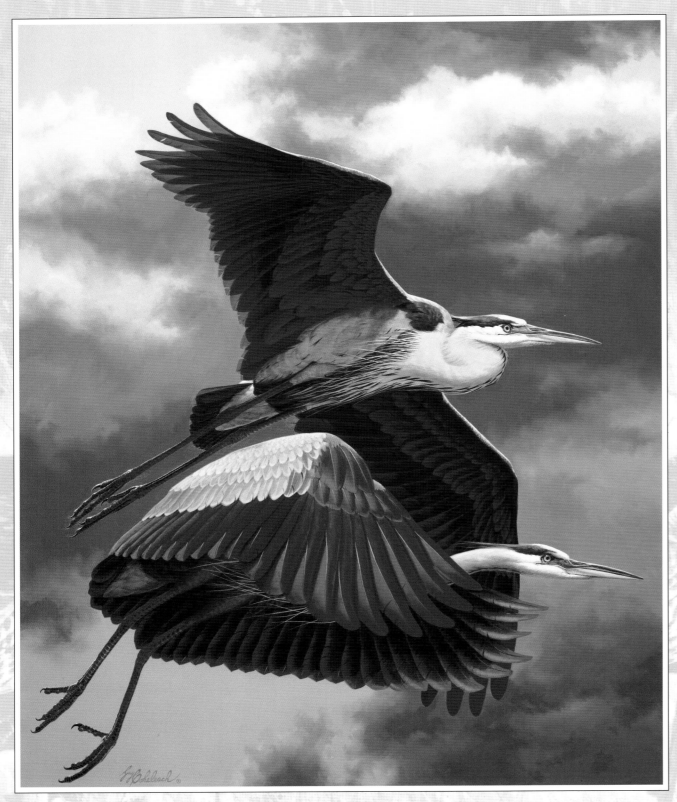

The Great Blue Heron
Acrylic on board • 34 x 28 • 1992

A painting can start out to be one thing and turn out to be something completely different — in this case, in more ways than one. Coheleach set out to paint a single great blue heron, with the intention of publishing it. Accordingly, he began with acrylic on his palette and a 30 x 40 masonite board on his easel...

When I finished the single bird, I just didn't like it. It looked to me like a fried egg sitting there on the canvas, so I put another one in there, then trimmed the painting. That's why the odd size. And then, I thought, it was really neat.

Unfortunately, his publisher did not agree and the painting was never printed. Coheleach then submitted it to Leigh Yawkey Woodson, and it became part of their travelling exhibition. Some things just don't work out; others work out better.

STRICTLY FOR THE BIRDS

The secret to iridescence is contrast and purity of color.

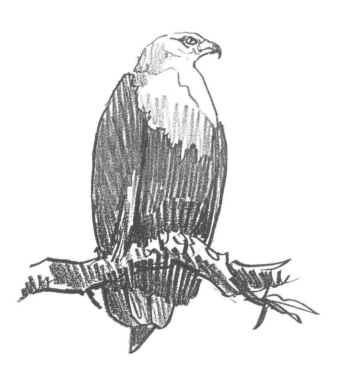

Here is a typical scene from the beaches of Long Island where Coheleach was raised. The northwest winds would come through, carrying big black clouds after breaking up a front.

One thing that impresses me about the peregrine falcon is its incredible speed and maneuverability. The greater yellowlegs is also a very fast bird. The peregrine has just come around the sand dune, and he's banking, with the tail making the turn.

Leaving the far-side wing out — which is hidden — implies much more action than putting the wing in.

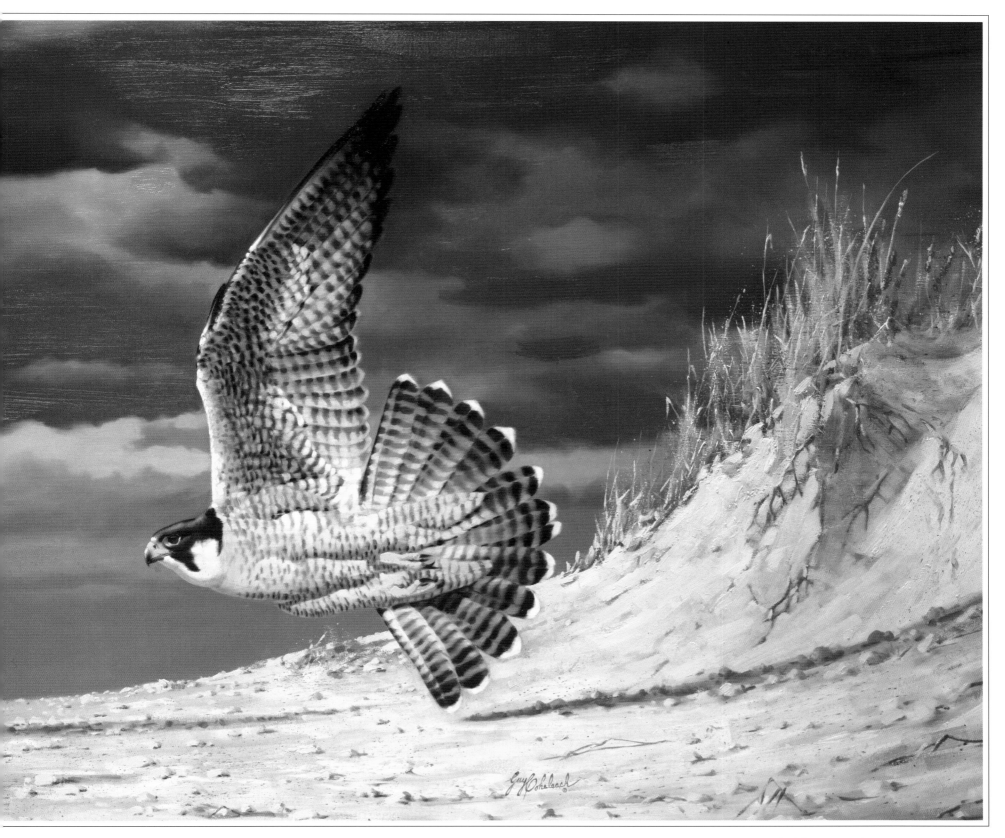

Barrier Beach Chase • Oil on canvas • 36 x 72

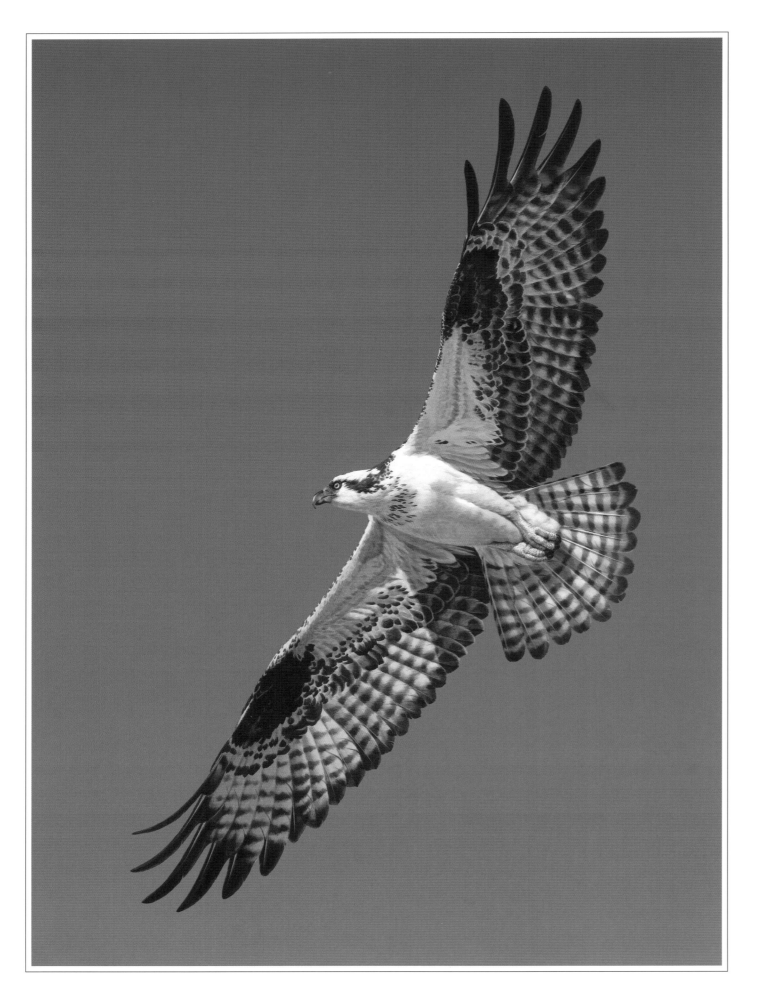

Osprey
Gouache and acrylic on
illustration board
40 x 30
Printed as poster: 1983

I love ospreys—everybody does. When I was a kid, before DDT found widespread use, ospreys were so common on Long Island that you could find their nests on the ground. I remember one giant oak tree on Orient Point that held three active nests. I used to watch the birds dive down out of the trees to snatch weakfish and bluefish—what marvelous hunters.

The osprey is a bird that you can paint from underneath. The underside of an eagle is relatively dark and uninteresting, but the black-and-white pattern of the osprey's plumage provides a nice natural design.

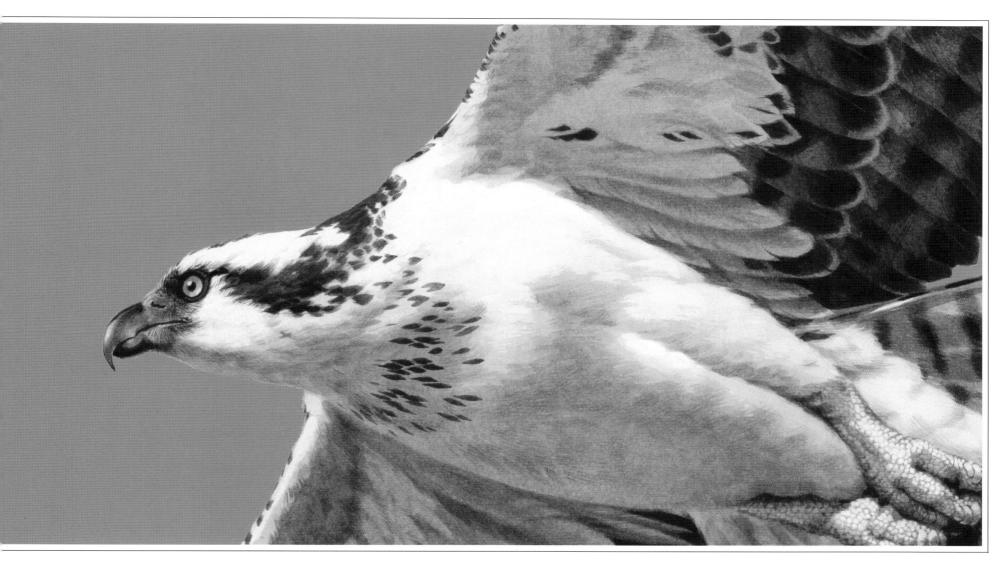

Detail from *Osprey*

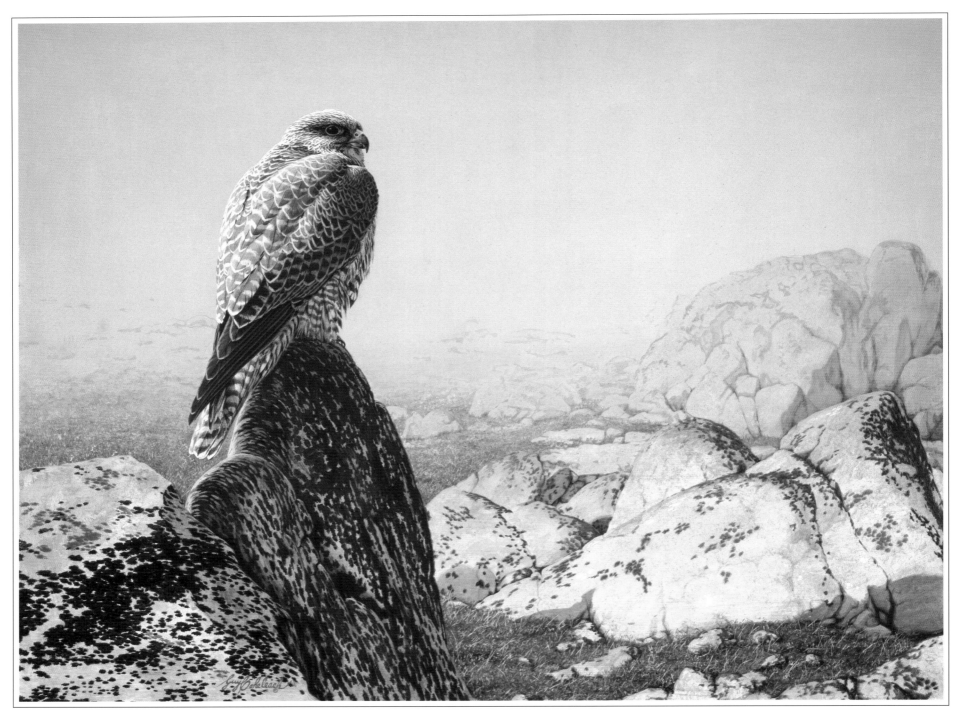

The gyrfalcon, the beautiful raptor of the arctic, comes in three color phases: white, gray and black. It is a popular subject for painters, but usually in its spectacular white or black phase, rarely in the gray. So Coheleach decided to be different.

In terms of numbers, in Greenland I think the white is the most common, and in the Canadian Arctic the gray is most common. The pure, slate black is really striking, but it is also the rarest of the three.

In terms of paintings, however, the gray is the rarest. Everyone likes to paint white or black because they are so beautiful, but no one paints the gray gyrfalcon.

The background comes from some photographs I took when I was up watching polar bears in Churchill, Manitoba. I really liked the rocks and thought they would be a great place to put a gyrfalcon.

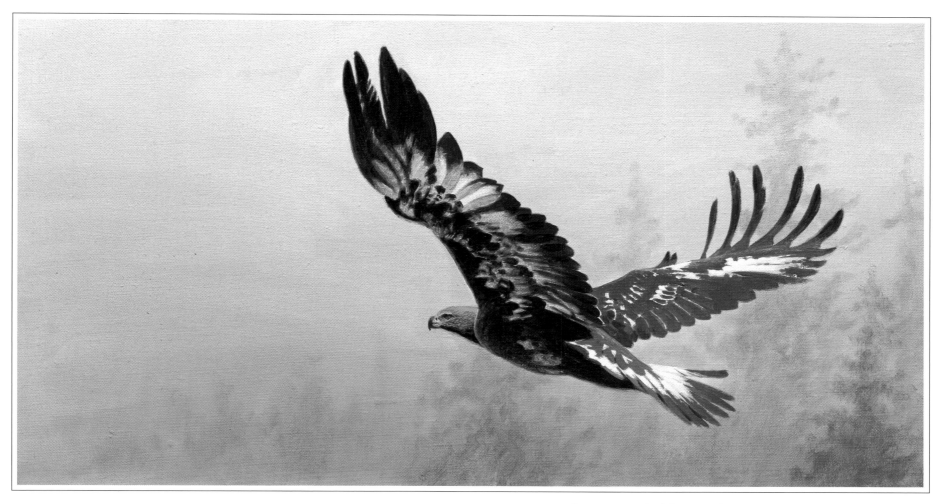

Immature Golden Eagle • Oil on canvas • 12 x 24 • 1989

Many of Coheleach's paintings come about because, on a particular day, he feels like painting a particular creature in a particular setting. On this day, he says, he just felt like painting an immature golden eagle.

I like painting the immature bird rather than the adults because the markings are easier to see. If you do a portrait (a close-up of the head) you prefer an adult because the gold hackles are fully developed and visible. The golden eagle breeds in the mountains and prefers to stay there, so the background could be any mountains in Canada or the Western United States, or even Appalachia. The misty background allows it to be anywhere the viewer wants it to be.

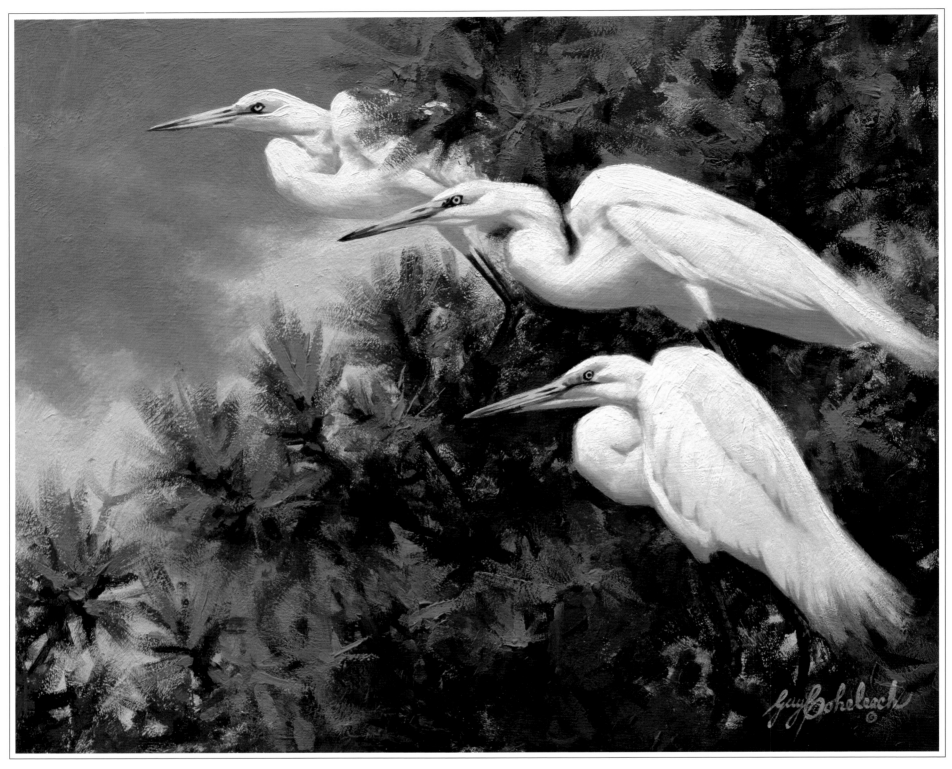

Three 'Grets (Egrets) • Oil on linen • 8 x 10 • 1988

Vanishing Grandeur
(Bald Eagle)
Acrylic on illustration board
40 x 30
Print: 1984

It is a magnificent bald eagle, swooping down through a turbulent sky toward its prey.

The bald eagle is a powerful bird and in this portrait I wanted to show a lot of force and motion. The clouds, if you study them closely, show an almost arrow-like direction to the left. This helps to convey the speed of the bird. Parting the clouds slightly also enhances the feeling of speed and direction.

When my publisher decided to make prints of this painting, they asked me to put mountains in the background. However, this is the way I like it, with just the clouds to impart a feeling of freedom and majesty.

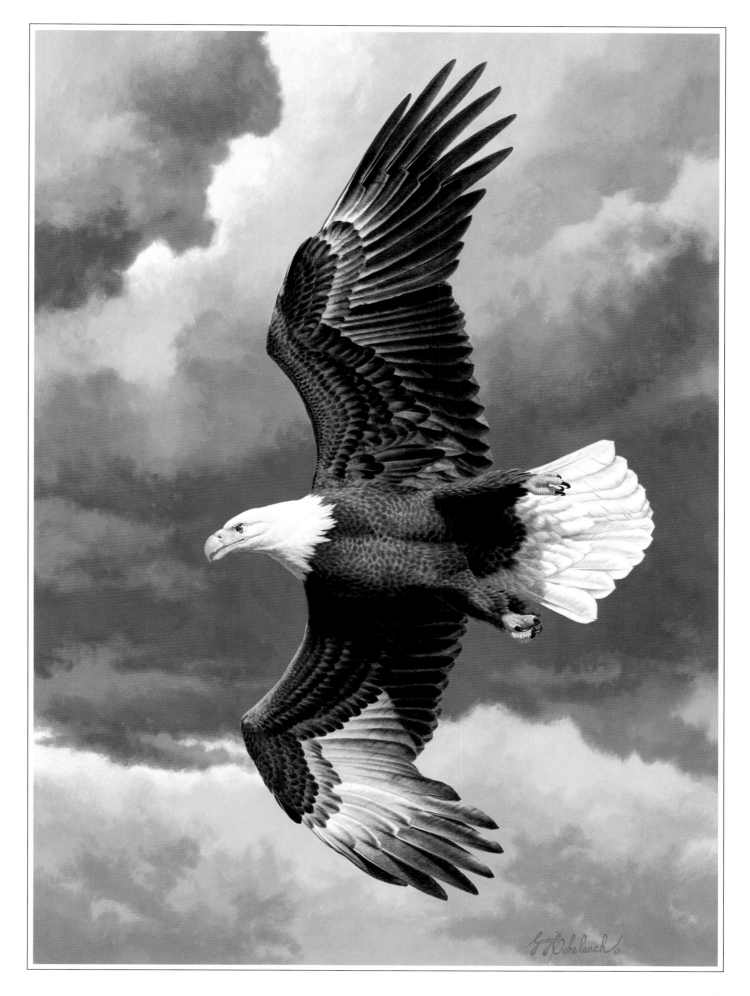

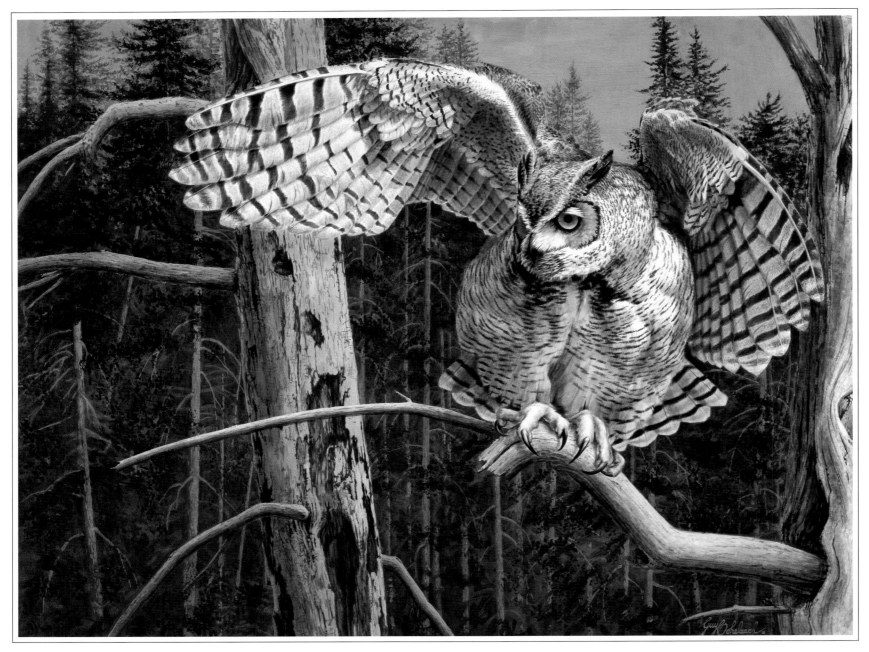

Balancing Act (Great Horned Owl) • Acrylic on board • 30 x 40 • 1990 • Print: 1991

In *Balancing Act,* the great horned owl has heard something behind him, and is turning to prepare to take off in that direction. Although the scene is quite bright, it is unmistakably nighttime. Painting the one while conveying the other is not easy.

Painting nighttime is very, very difficult. Few artists have ever done it really well, and I am not including myself among them. There are various approaches, such as painting more or less normally but subduing the light so you get the feeling that it's a moonlit night. That's one way.

You don't have to paint owls at night. If they are hungry, they hunt during the daytime — in among the trees, of course, so it is still pretty somber. Owls do not sleep like we sleep. Like cats, they are always alert, so it would be quite realistic to paint an owl in a tree during daytime, with his eyes open.

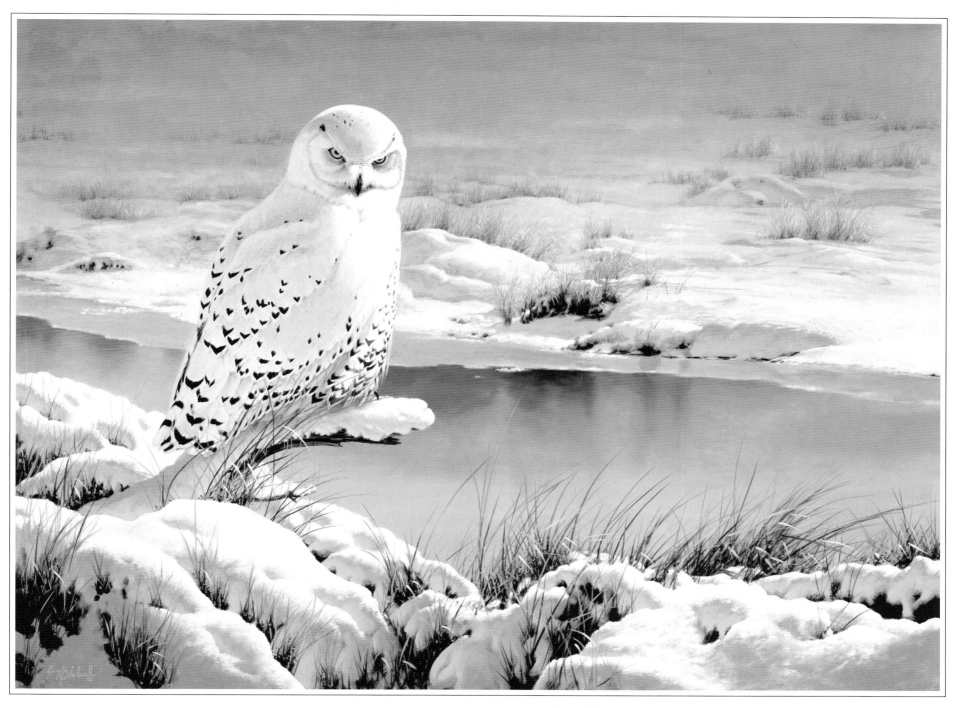

Rare Visit (Snowy Owl) • Oil on canvas • 22 x 30 • Print: 1992

I can remember snowy owls from my boyhood days on Long Island. During winters when lemmings and voles were scarce in the Canadian provinces, these magnificent birds would drift southward into the States to search for food. I can still see their ghostly forms gliding across the dunes.

In this case, I did not know which background I liked better, the woodland with the stream or the very bleak, frozen meadow with the stream. So I did both.

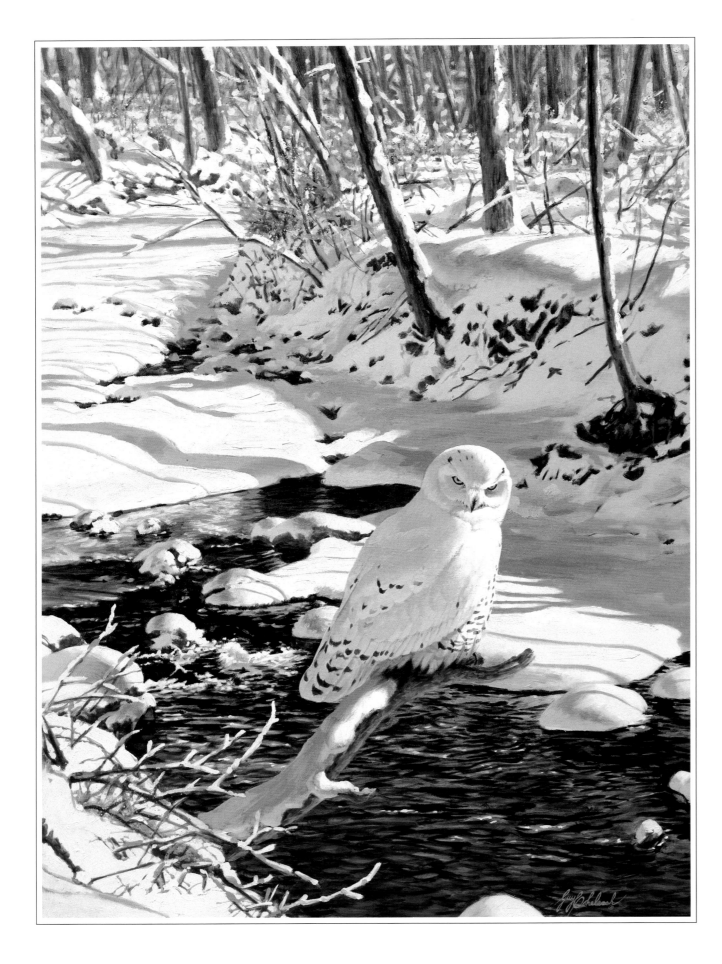

White on White (Snowy Owl)
Oil on canvas • 30 x 22

White on White is similar to **Rare Visit** – another instance of Coheleach exploring one theme from different angles.

The snowy owl is a creature of open spaces. Here, I have used artistic license to portray it in a more interesting setting, an ice-choked stream and snowy woods that accentuate the bird's mottled plumage.

Barrier Beach Owl • Oil on canvas • 22 x 18

These birds migrate to the dunes on Long Island in harsh winters where there are these snow fences. The different patterns make very interesting designs. This is another variation on that theme.

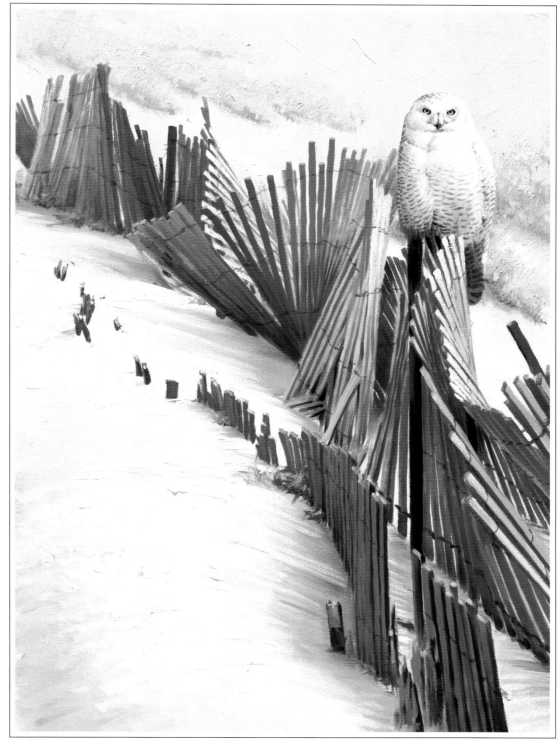

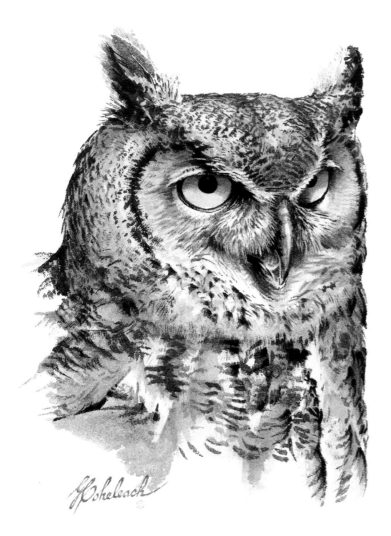

Great Horned Owl • Watercolor on paper • 10 x 8

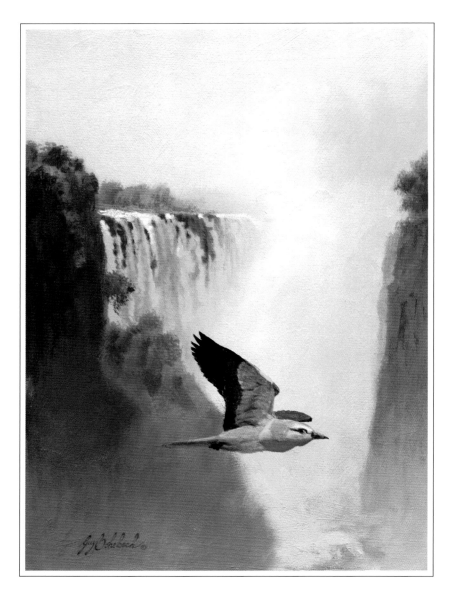

Victoria Falls (Lilac Breasted Roller)
Oil on canvas • 12 x 9

If God told me to invent heaven, Kilimanjaro and the Matterhorn would be behind the magnificent Victoria Falls. Here a lilac breasted roller flies across the Devil's Cataract.

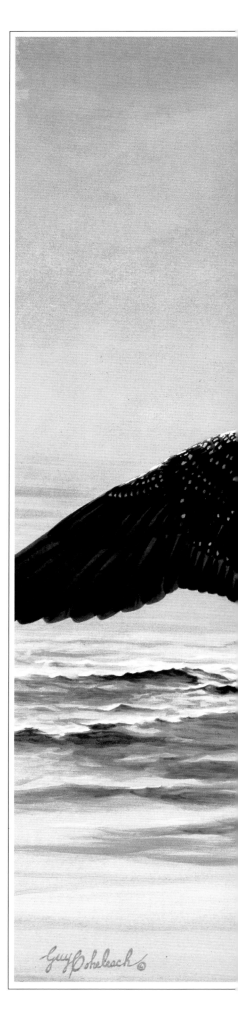

Jewels of the Lake (Loons)
Acrylic on board • 30 x 40 • 1990
Print: 1991

Although common loons are a very popular subject for wildlife prints, Coheleach has not painted many and this is his only loon print. The painting was created specifically for a print. When a painting is intended from the start for print reproduction, Coheleach almost always uses acrylic on board, 30 x 40. In this case, the challenge was to paint a loon unlike all the other loons on the market.

Most renderings of loons have them floating along on a glassy lake. What I painted is a common enough pose for loons, but there are not many photographs of them doing this. To paint them accurately in this pose, you have to sit down with the study skins and the bones, spread them out and draw them very carefully.

The result of this extra effort is a most dramatic and beautiful loon painting.

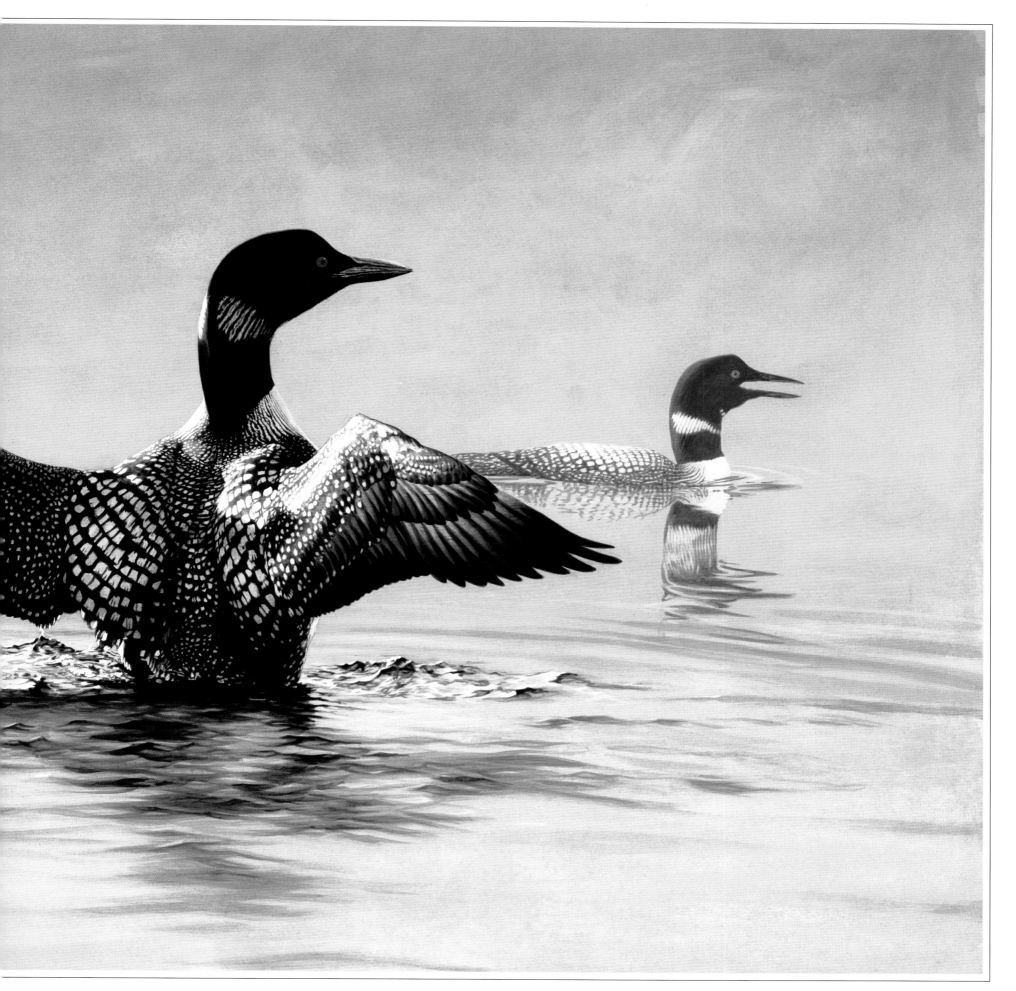

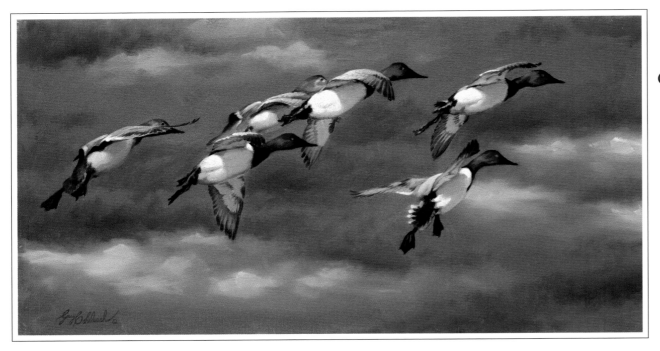

Cans • Oil on canvas • 12 x 24

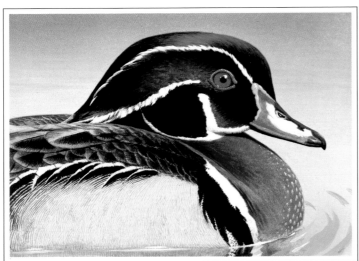

Drake Wood Duck
Gouache on illustration board • 7 x 9

Aloft In The Yellow Glow • Oil on canvas • 9 x 12

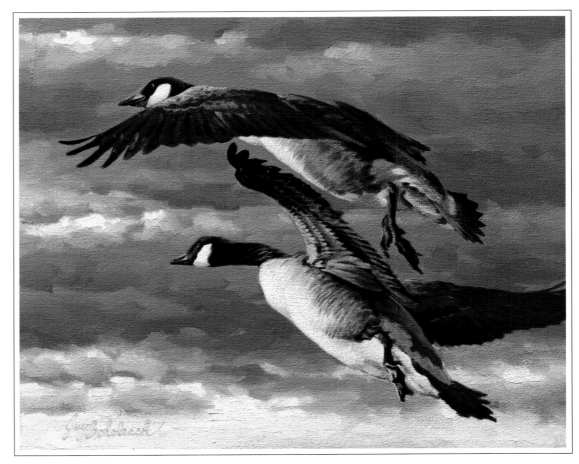

The secret to iridescence is contrast and purity of color. I find the glaze approach works best. You can make a color much brighter if you apply it over white rather than mixing the two.

For example, you can paint the green on the Wood Duck's head by laying down an opaque mixture of green and white. Another technique would be to paint it black or dark purple, then add transparent green over that.

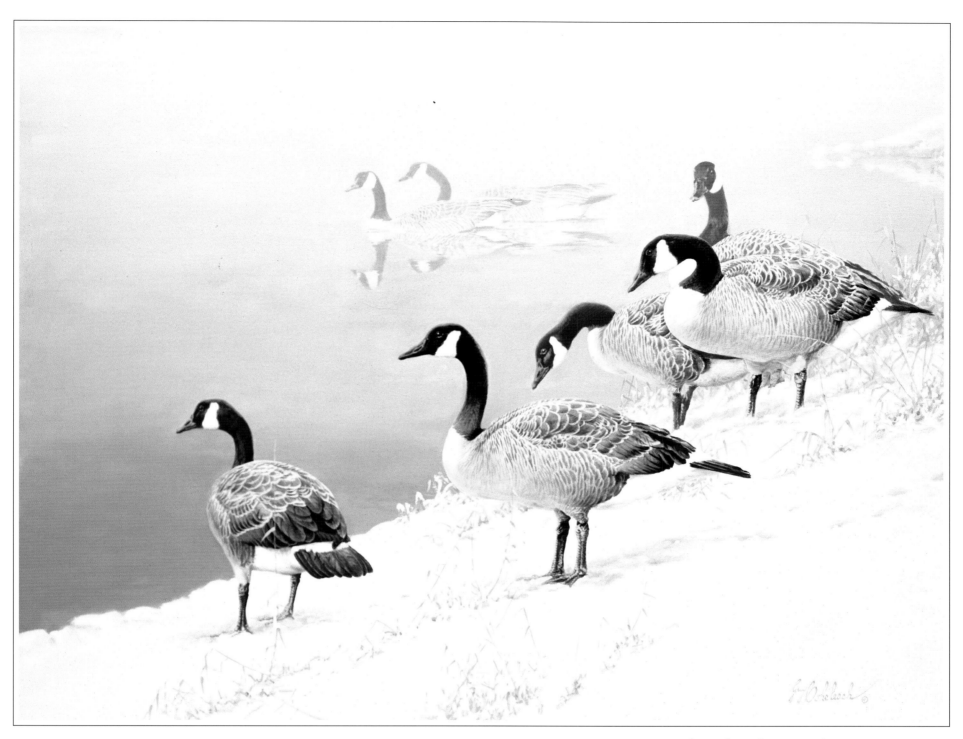

Canadian Geese • Oil on canvas • 30 x 40

When the book *Coheleach* appeared in 1989, a viewer fell in love with a painting of Canadian geese. It was not available, so Coheleach painted a similar one with the geese in a different setting.

I don't like to paint exactly the same subject twice if I can avoid it, but doing a similar subject is sometimes a lot of fun because you can try out some different ideas.

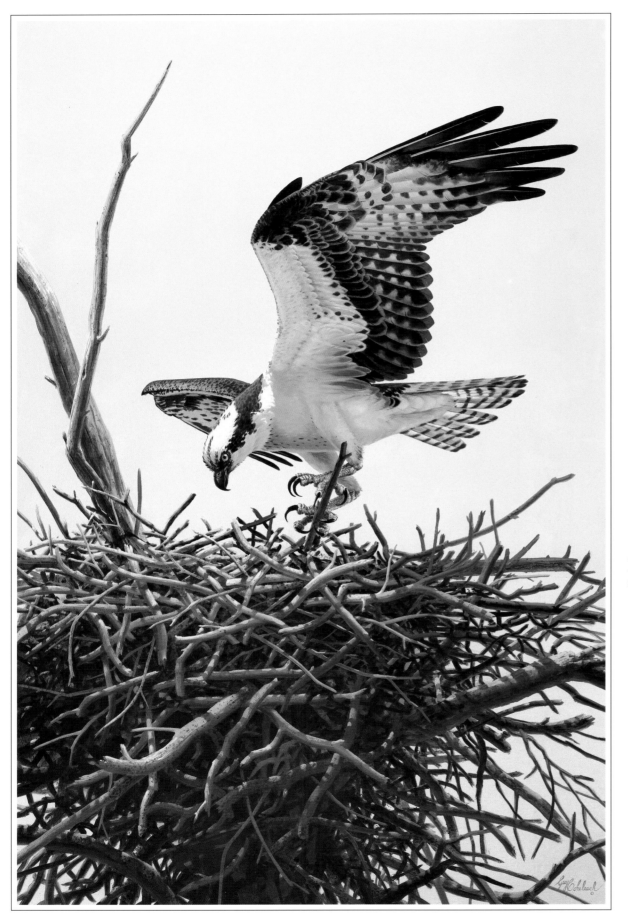

Building the Nest (Osprey)
Oil on canvas • 72 x 48 • 1990

Ospreys are among Coheleach's favorite
subjects, dating back to childhood and his first
efforts at painting wildlife. They are
circumpolar, and were common visitors to
Long Island when he was growing up.

*I love painting ospreys, and just wanted to
paint one building a nest. An osprey is an
osprey, so it could be anyplace. When I was
growing up, though, there were hundreds that
nested at Orient Point on Long Island. Then
the pesticides almost wiped them out. They've
come back now to a great degree, but they will
never be as numerous as they once were
because pollution has wiped out so many of the
fish.*

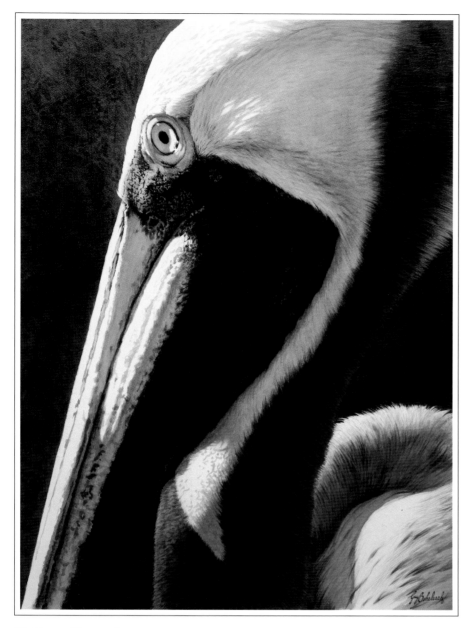

Pelican Portrait
Watercolor
30 x 24

Brown Pelicans
Oil on illustration board
18 x 6

This was a painting earmarked for charity, in this case an auction for a local arts council in Florida. Coheleach set the mood with his choice of color for the watery background.

The pelican heads are a warm, yellowish white. The complementary color of yellow is purple, so to get the effect I wanted, I needed to make the water purple and that is why there are all the pinks and lavenders.

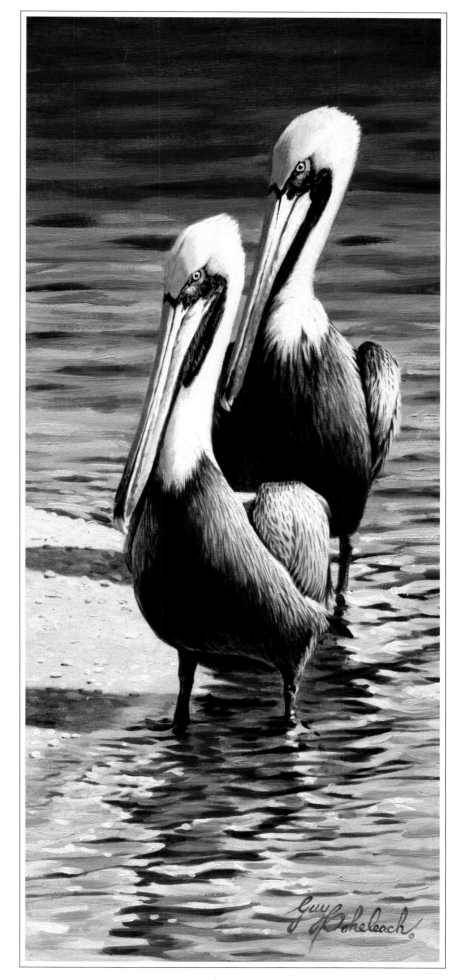

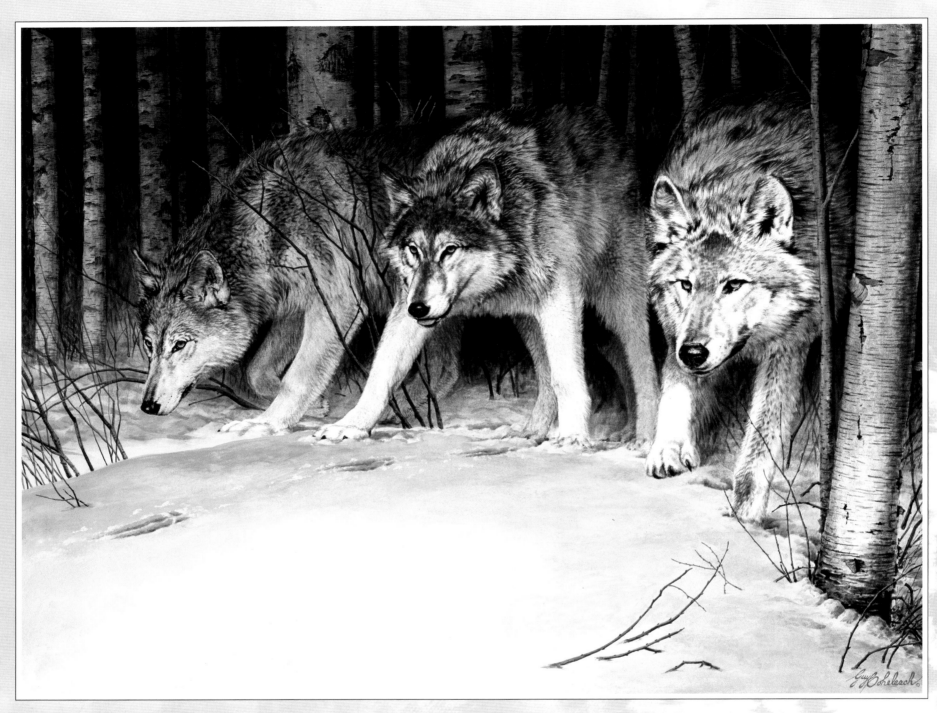

Serious Business (Wolves)
Acrylic on board • 30 x 40 • 1990 • Print: 1990

Wolves are an evergreen subject for print publishers, possibly the all-time most popular animal among print buyers. Coheleach has no ready explanation for their popularity, but agrees that it cannot be simply dismissed as a fad.

This popularity works against an artist looking for an original idea. Coheleach fell back on a theme he knows better than anyone: The predator/prey relationship. The prey, a deer, is suggested by the tracks in the snow. The wolves on its trail are intense. There is not a benign hair on their bodies, and the viewer is not tempted in any way to reach out to pet one.

I once said, half jokingly, that my favorite way to paint a cardinal was in the talons of a goshawk. I was mostly serious, though, because the predator/prey relationship is almost as important to me just as it is the ultimate activity of the two parties to the chase.

THE CHASE
PREDATOR & PREY

Capture an animal in the midst of hunting for food or escaping from a predator, and you capture it at the very height of its being — its most alert, its most intense.

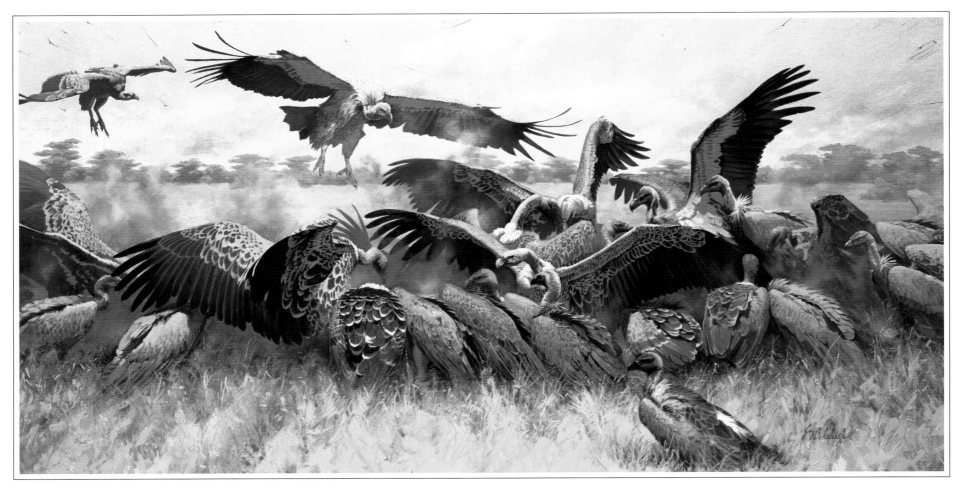

Attorneys and Bankers • Oil on canvas • 36 x 72 • Print: 1987

A large painting in every way, with a great deal of texture and, most of all, a great deal of frantic action, *Attorneys and Bankers* was painted just after a period of legal turmoil in Coheleach's life.

Africa is a tough place. Even the king of beasts has to worry about the hyenas, and the hyenas worry about each other. The vultures want to get in on the action after the lions, but ahead of the hyenas and jackals because they can't fend them off. And, they have to compete with each other.

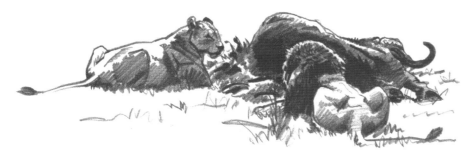

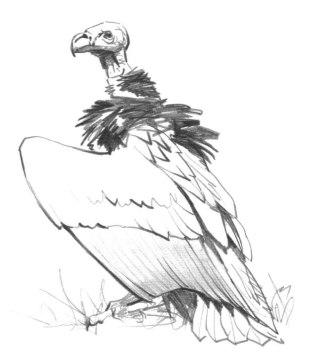

I grew up in a large family, and I got my hand slapped if I reached for something ahead of somebody else, before it was passed to me. I learned very quickly, since I sat next to my father's right hand. Vultures do not have that problem; if they are to survive, they have to get as much food as they can as fast as they can, between the time the lion leaves and the other scavengers arrive.

The vulture's head and neck are very snakelike; devoid of hair and feathers, they are easy to clean after a typically rowdy and frenetic meal.

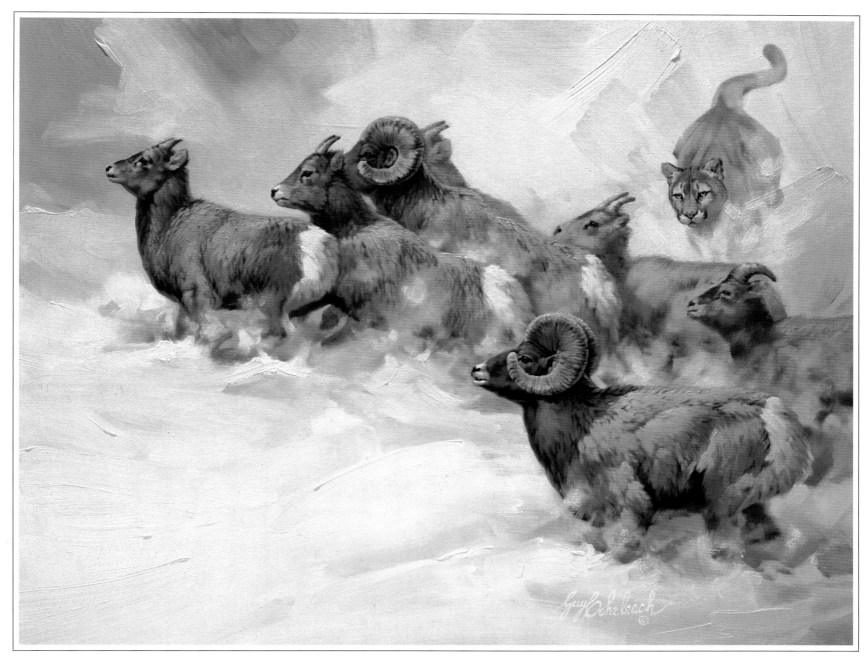

Rocky Mountain Chase • Oil on canvas • 30 x 40 • Print: 1981

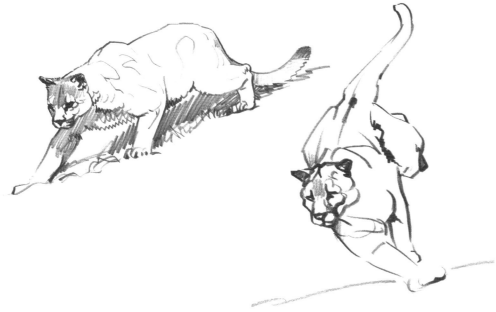

*T*his was originally painted with just the bighorn sheep, but when I needed more puma paintings for the cat book, I went back in and added the cougar.

I like the explosive quality in the painting, the spontaneity, the **boom** look that the brushstrokes give to it…like a flock of quail exploding into the air. This is really the way I like to paint. I could have put in every little hair and left the background as it is, but it all ties together better by conveying the animals with loose, painterly strokes.

I have many favorite paintings. Some I like for their grandeur, others for their subtlety. There are those I prefer for their mood or detail; others for their painterliness.

Siberian Chase *stands out because it became my favorite print. It proved to me that collectors of wildlife art will buy something other than pieces with fur and feathers rendered in meticulous detail.*

I have always liked to work impressionistically, but I had never had the nerve to print such a painting. **Siberian Chase** *was proof that at least some buyers were ready for more fine art in their limited edition prints. I am sure there are better works of art among my paintings, but there is none I remember as fondly.*

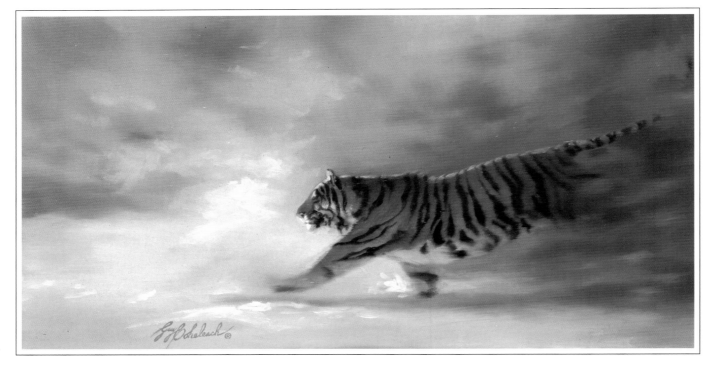

Siberian Chase • Oil on canvas • 10 x 20 • Print: 1979

In this portrait of two Siberian tigers, the long shadows in the snowy foreground enhance design and movement. Coheleach painted two tigers rather than one to depict the fluid motion of the big cats.

It's like painting two or three birds in flight: you show one with the wing up and one with the wing down. The shape of one shows you what the other will be in an instant; as a result, you can almost see them moving across the canvas.

In other paintings where the predator is the subject and Coheleach has not wanted to detract from it by including the prey, he has suggested the fleeing creature by clouds of dust or snow, or by feathers floating down in the air. Here he uses a variation on that technique, indicating the prey by tracks in the snow.

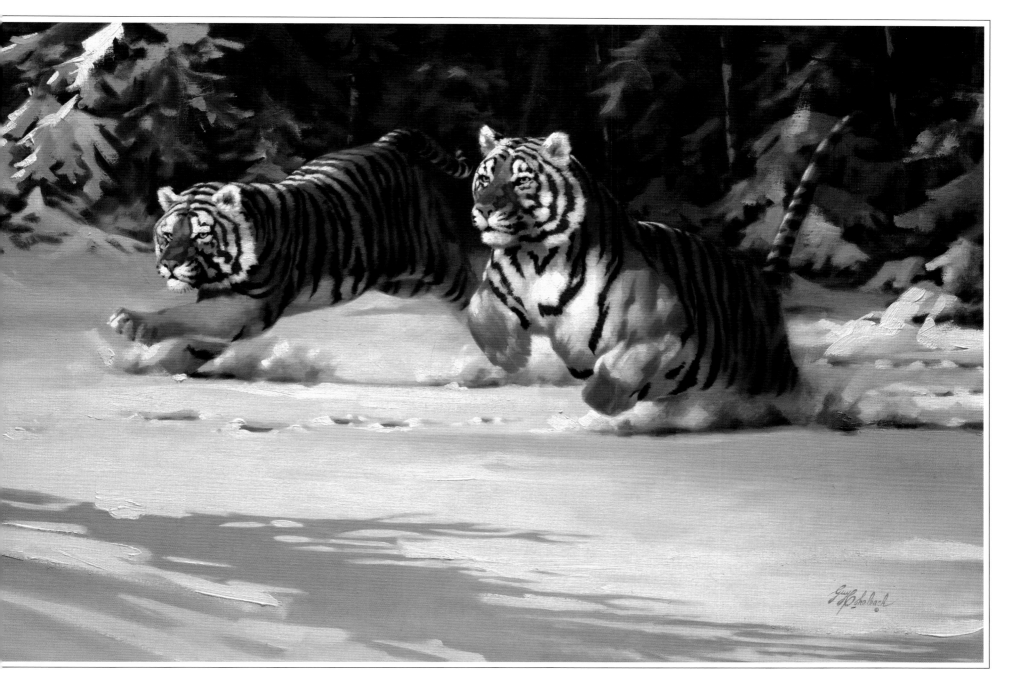

Manchurian Chase • Oil on canvas • 24 x 44 • Print: 1981

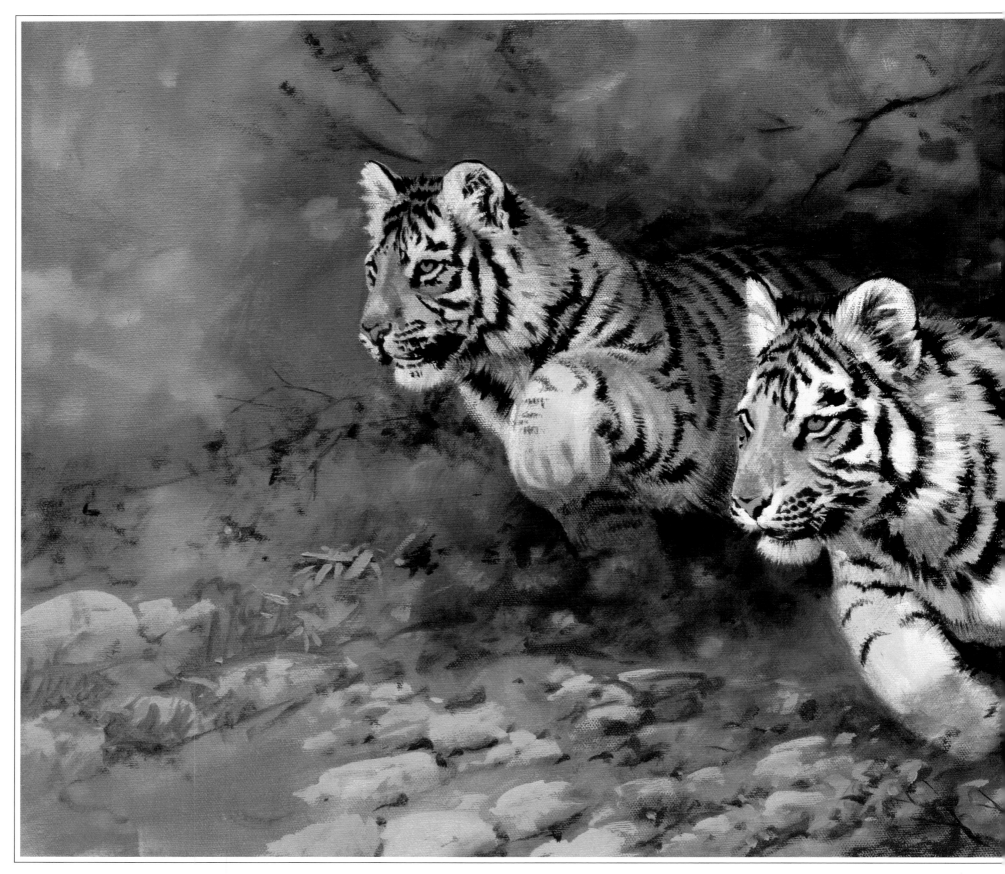

Juvenile Ambush (Bengal Tigers) • Oil on canvas • 15 x 30 • 1992

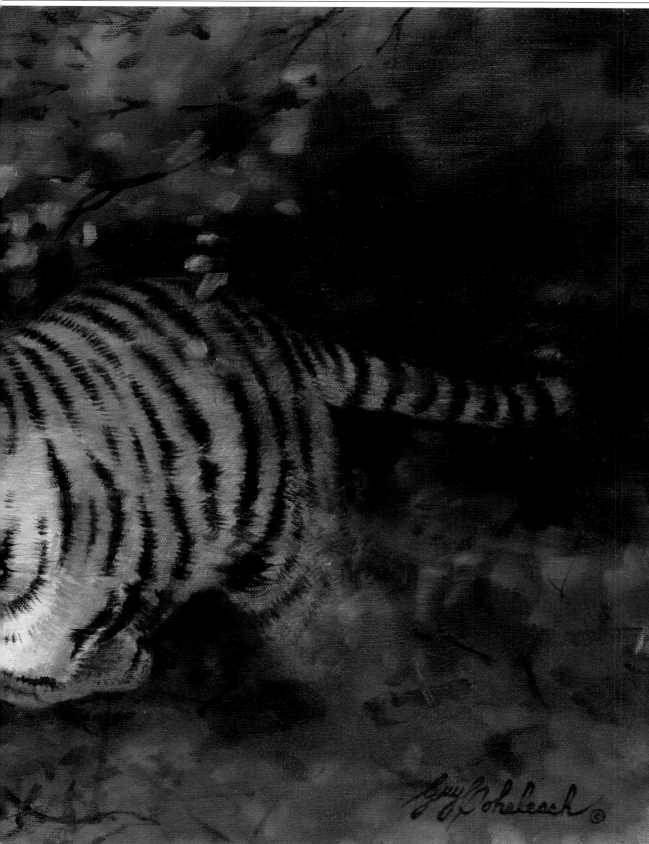

This is a painting with a great deal of action and not much detail. A common fault with many wildlife paintings is not the detail in the subject, it is having a highly detailed background that distracts the viewer.

This painting shows how a background which is out of focus causes the eye to concentrate on the subject and magnifies its interest, in this case almost causing the two young tigers to leap out from the canvas. So forceful are they, the painting seems three dimensional.

This is a variation on a theme that I began years ago with **Siberian Chase** *and followed with* **Manchurian Chase**.

I just love painting tigers. I don't need any other reason for doing it.

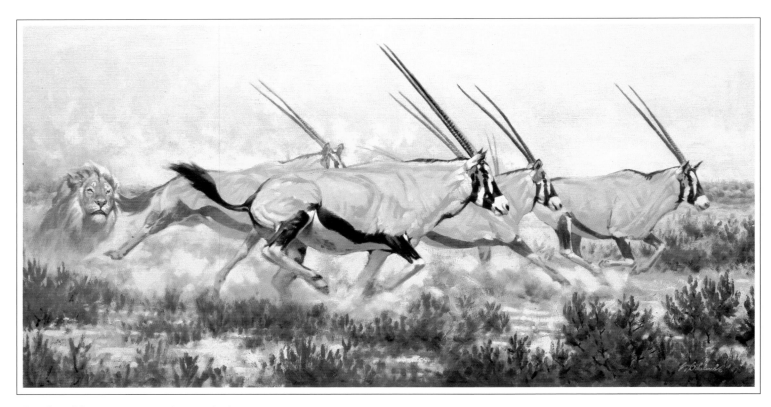

Etosha Chase (Lion and Gemsbok)
Oil on canvas • 18 x 36 • 1991

The predator/prey relationship has been a subject of intense interest to Guy Coheleach his entire artistic life.

Gemsbok are a subspecies of oryx found in southern and southwestern Africa. Although a handsome antelope, they are not often the subject of paintings – but then, in this case, they are not really the subject of the painting, either.

This was really just an excuse to paint another lion without seeming to paint a lion.

Still, the gemsbok is a good subject. There is something very striking about the pattern, especially when you see them running, and I had recently watched them running in Etosha (Namibia). When you go there during the dry season, it is easy to see game. It is bright, there's very little cover as you can see, and the gemsbok really stand out. The lion, on the other hand, blends in beautifully.

When a group of us were in Namibia in May 1992 we witnessed the unbelievable sight of a leopard killing a young kudu and in the process running between the legs of a very startled giraffe! I would not dare paint the incident as we saw it; no one would believe it. **Chobe Chase** *is one of three paintings of leopards chasing antelope that resulted from that experience.*

Chobe Chase (Leopard and Impala)
Oil on canvas • 18 x 22 • 1992

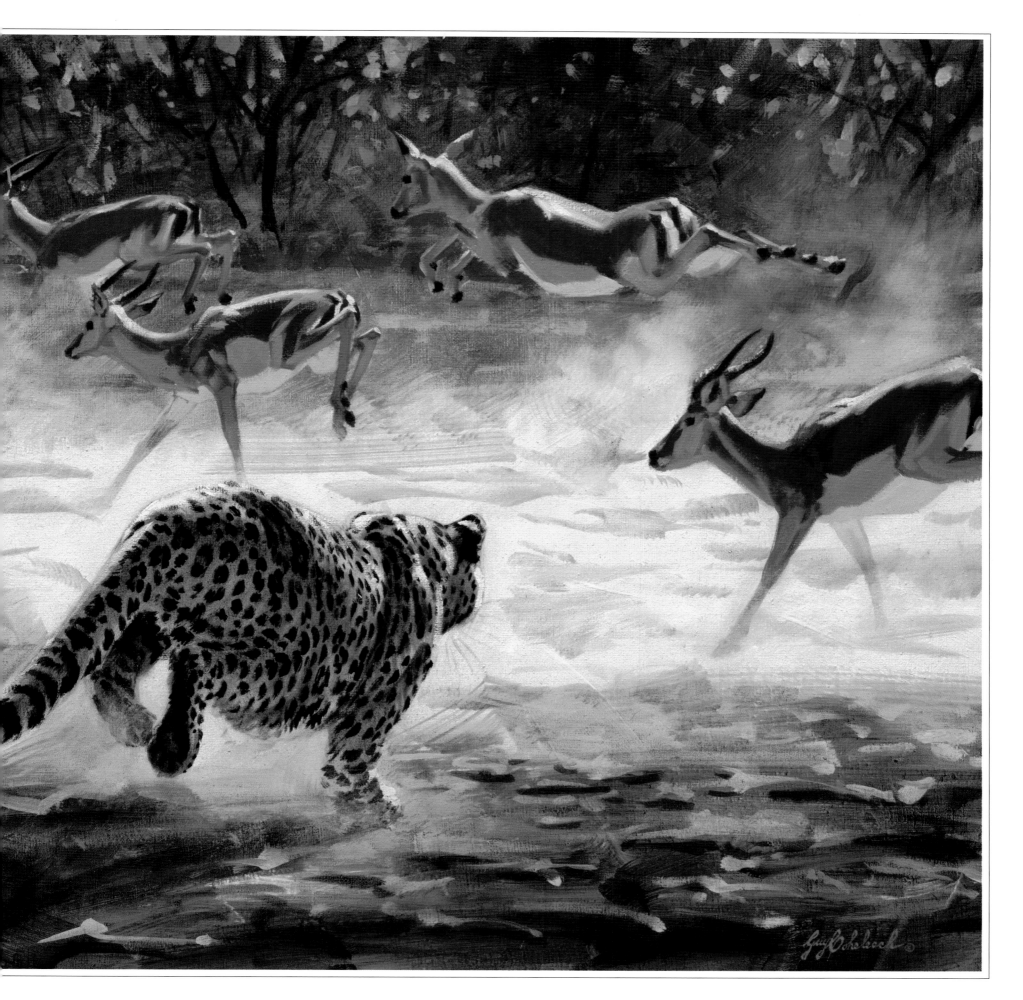

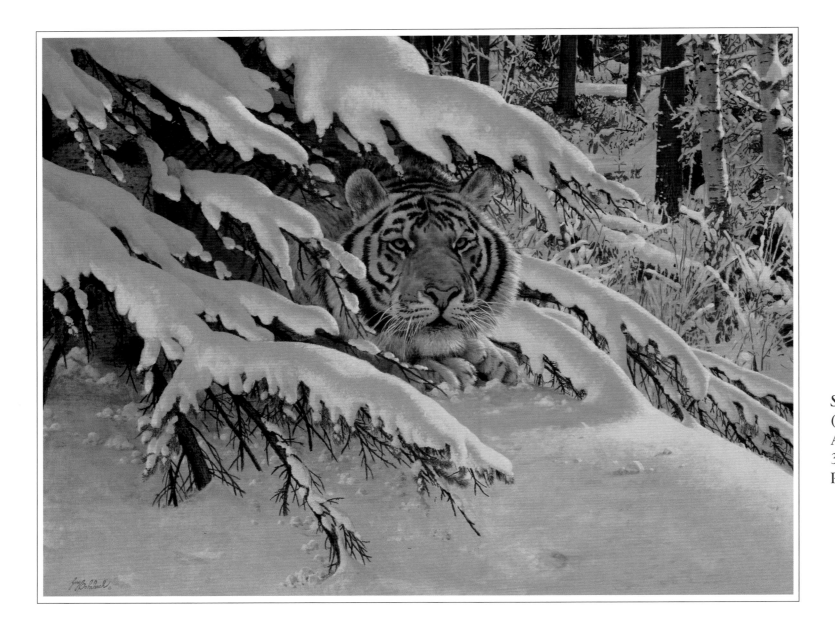

Siberian Ambush
(Siberian Tiger)
Acrylic on board
30 x 40
Print: 1992

Guy Coheleach has a personal affinity for the big cats, and perhaps for the Siberian tiger most of all. His personal stationery bears a portrait of a Siberian tiger, and he never seems to go for long without painting one.

In this case, I wanted to paint a portrait of a Siberian tiger, because I simply love the things. But I also wanted to paint one in an alert, crouched position.

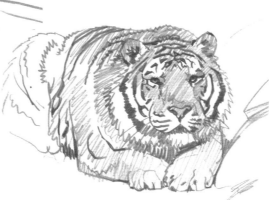

You can tell that this is a Siberian tiger simply by the snow, of course, but there are other ways, too. The Siberian is taller in the shoulder and perhaps a little broader in the skull than the Bengal, but those are not easily recognizable in a painting. What is recognizable is the fact that the Bengal tiger is not as pale as the Siberian — it is a richer red, and the hair is shorter when it is in the wild.

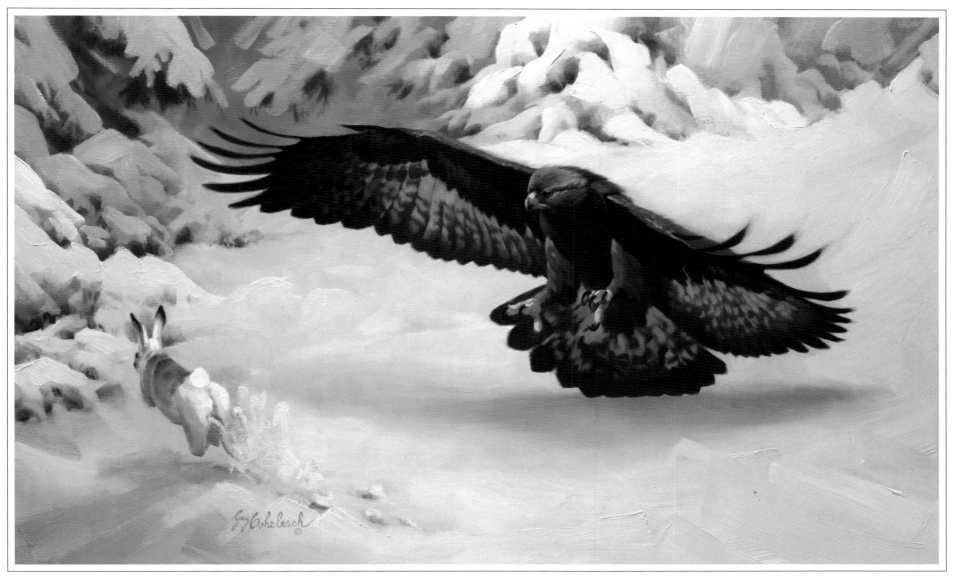

Haree Moment • Oil on canvas • 36 x 72 • Print: 1980

Paintings of wild animals can range from detailed portraits to broad impressions with bold, almost gloppy brushstrokes that create a particular mood or atmosphere.

In *Haree Moment*, Coheleach depicts a golden eagle swooping down on a snowshoe hare. The eagle's wingtips and the hare's bounding form are a blur of motion. To heighten the drama, he detailed the raptor's fierce expression and outstretched talons.

The painting works because of its breathless spontaneity—it's like the viewer has just rounded a woodland trail to see the life and death drama unfold.

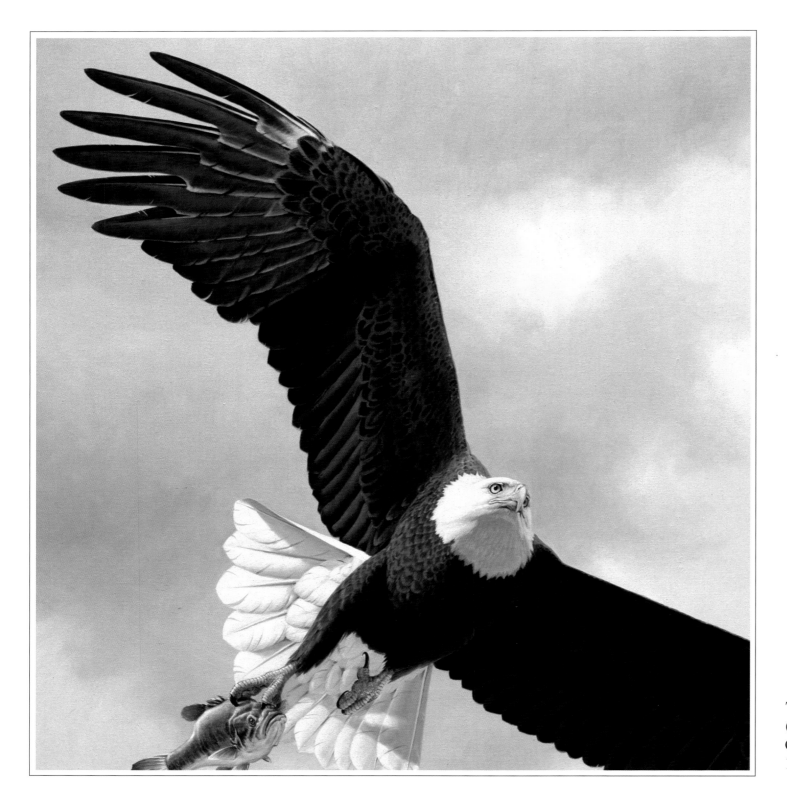

Tudor Meadow Fisherman
(Bald Eagle)
Oil on canvas • 72 x 48
1990

The bald eagle (or American eagle, as it is now frequently called) is a favorite subject for wildlife artists, Coheleach among them. Birds of prey were his first great interest when he began studying wildlife as a child.

The reproduction you see here is a photograph of the painting, taken after the eagle was painted but before the background was put in. I was fascinated by the simplicity of it.

The finished painting showed Tudor Meadow with Maryland in the background, hence the name.

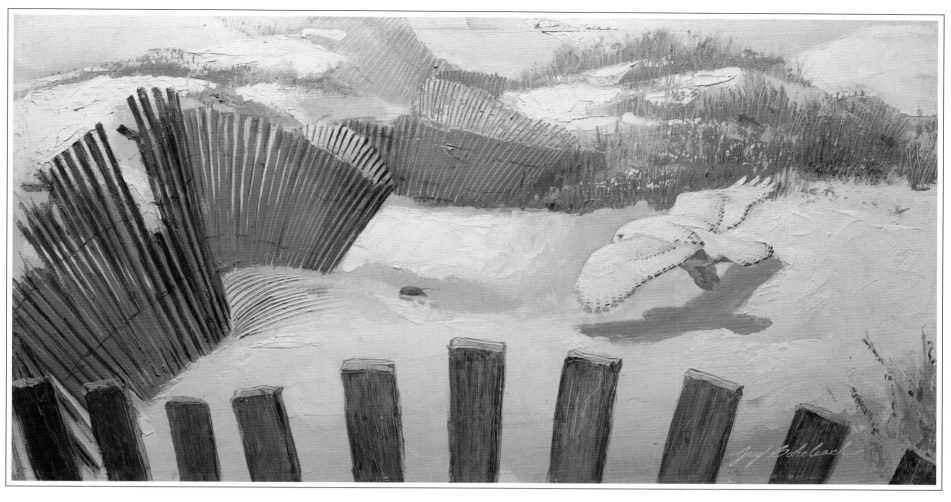

Snow Chase (Snowy Owl) • Oil on illustration board • 12 x 24

This is the type of painting I would never dream of putting out as a print, and yet it is probably one of the finest pieces in the book.

It is a small painting, done in 1963, and almost exclusively with a palette knife. It is essentially a painting of design, of mood, of texture and technique. The fence in the foreground breaks up the big white block of snow on the bottom, and frames the mouse and owl. The end result of the chase is left to the viewer — whether the mouse escapes or the owl eats.

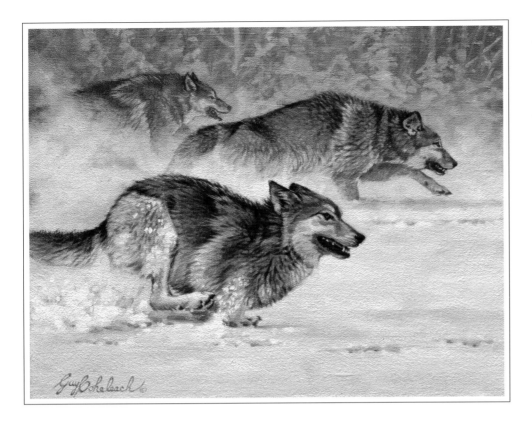

Fifty Yards and Closing (Wolves)
Oil on canvas • 9 x 12

*T*his was painted for a miniature art show and the idea graduated to a larger painting called **30 Yards and Closing**.

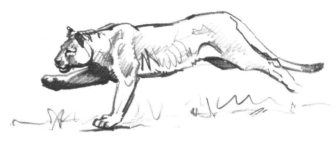

*L*ike so much of my work I just could not leave these wildebeest alone to run by themselves. I had to put in a predator.

Serengeti Chase (Wildebeest & Lions) • Oil on canvas • 24 x 44

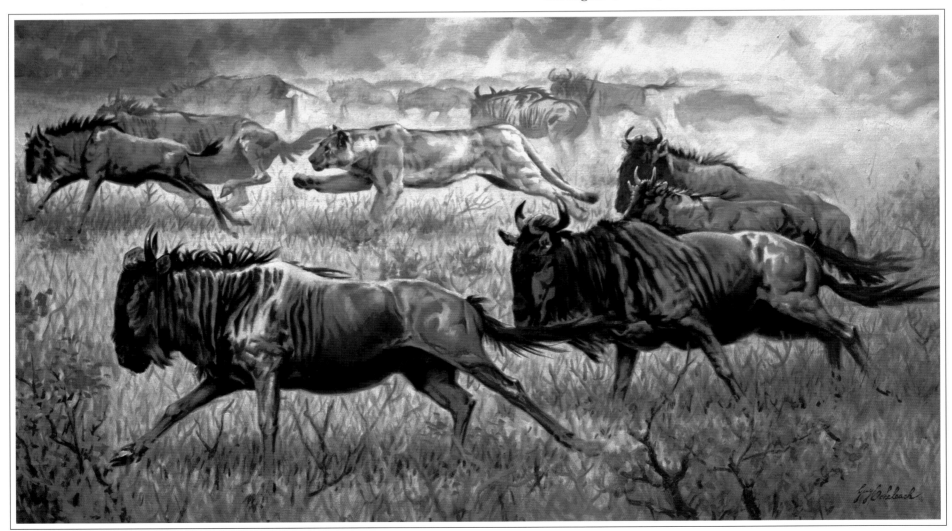

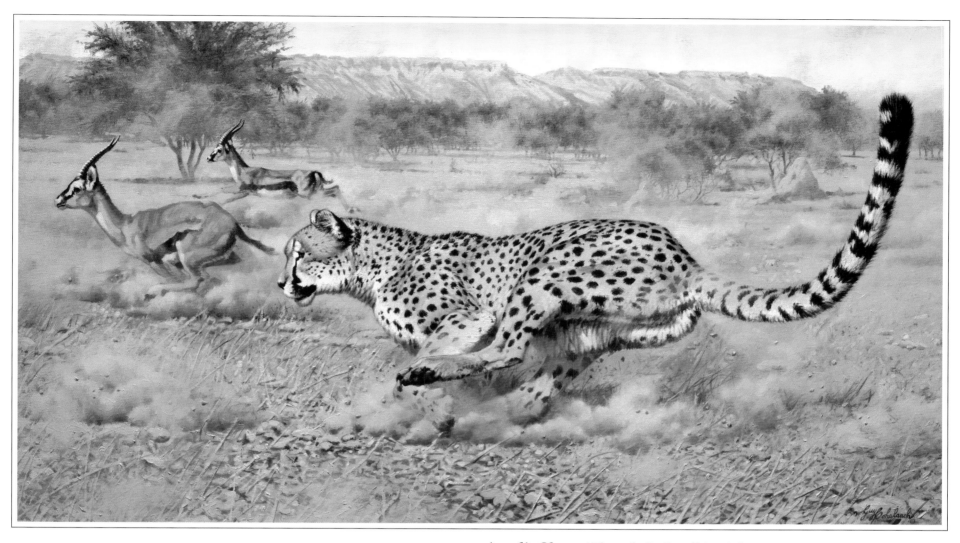

Angel's Chase (Cheetah & Gazelle) • Oil on canvas • 24 x 44 • Print: 1988

Angel, the star of **Angel's Chase**, is also a star attraction at the Cincinnati Zoo. In 1987 Coheleach was asked to paint a portrait of Angel, but in a wild setting. The result was **Angel's Chase**, which came about only after the artist worked out several technical and compositional problems.

First of all, the markings. To do a portrait of an individual, like a cheetah or zebra, each mark must be in exactly the right position. That's not a problem if you have a good photograph to work from and you paint the animal in the same pose. But to do that with the animal in a totally different position, allowing for perspective and muscle movement, can be an exercise in extreme frustration.

My second problem was even worse. I wanted to portray the cheetah in a chase scene, but she had to be large enough to be the focal point. If I put her behind the Thompson's gazelle, close enough that she was still important, she would have to be leaping to make a kill. But I didn't want to depict that actual half-a-second before a cheetah strikes. There are many people, even though they like the cheetah, who want to see the gazelle escape. I considered turning her head and having her chase one of the other Tommies, but then all you would see was the back of her ears. If the gazelle was coming at you, he'd be more important than the cat.

Coheleach solved the problem by having Angel pursuing a gazelle that is one step beyond the canvas; only a spurt of dust from its heels remains. Angel is the unquestioned hero of the painting, and the gazelle's fate is left to the proclivities of the viewer.

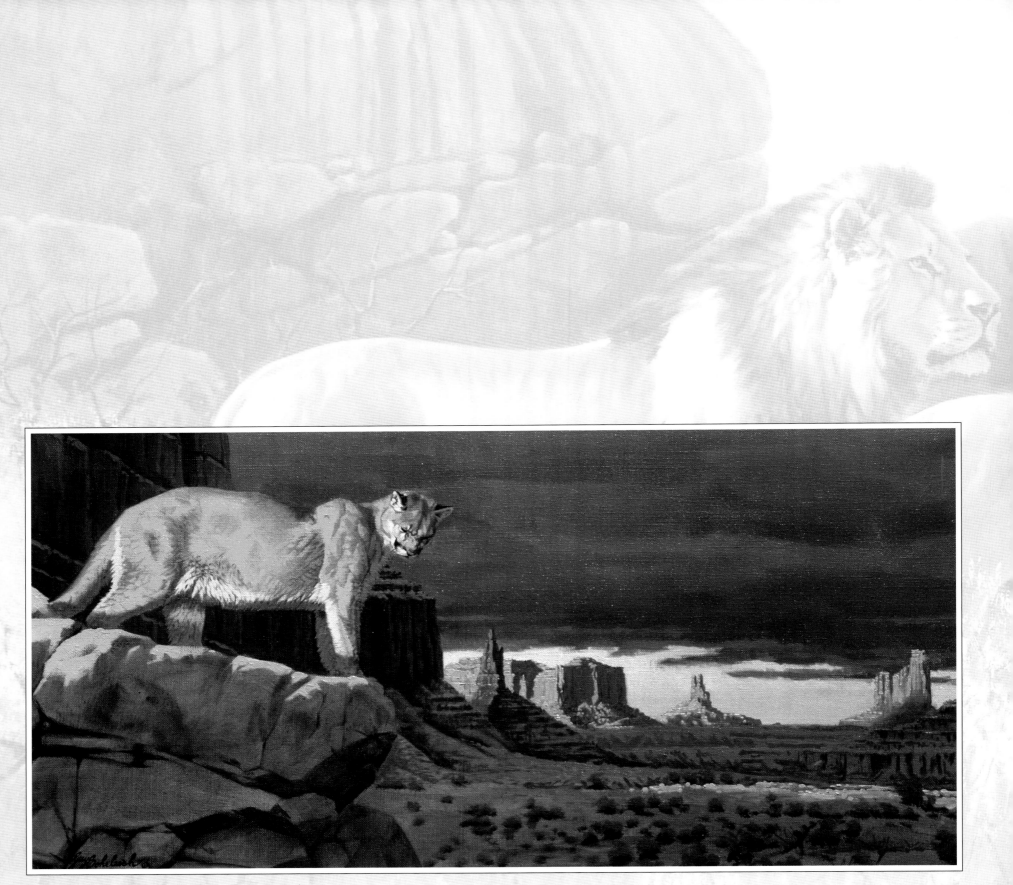

Navajo Cougar (Cougar) • Oil on canvas • 12 x 24

Anyone who has been to Monument Valley should identify with my need to paint it. Awesome is the only way to describe it. This is the first of what I'm sure will be many paintings of the area. What better predator to drop in than our country's version of a lion.

THE CAT'S MEOW

Although big cats don't.

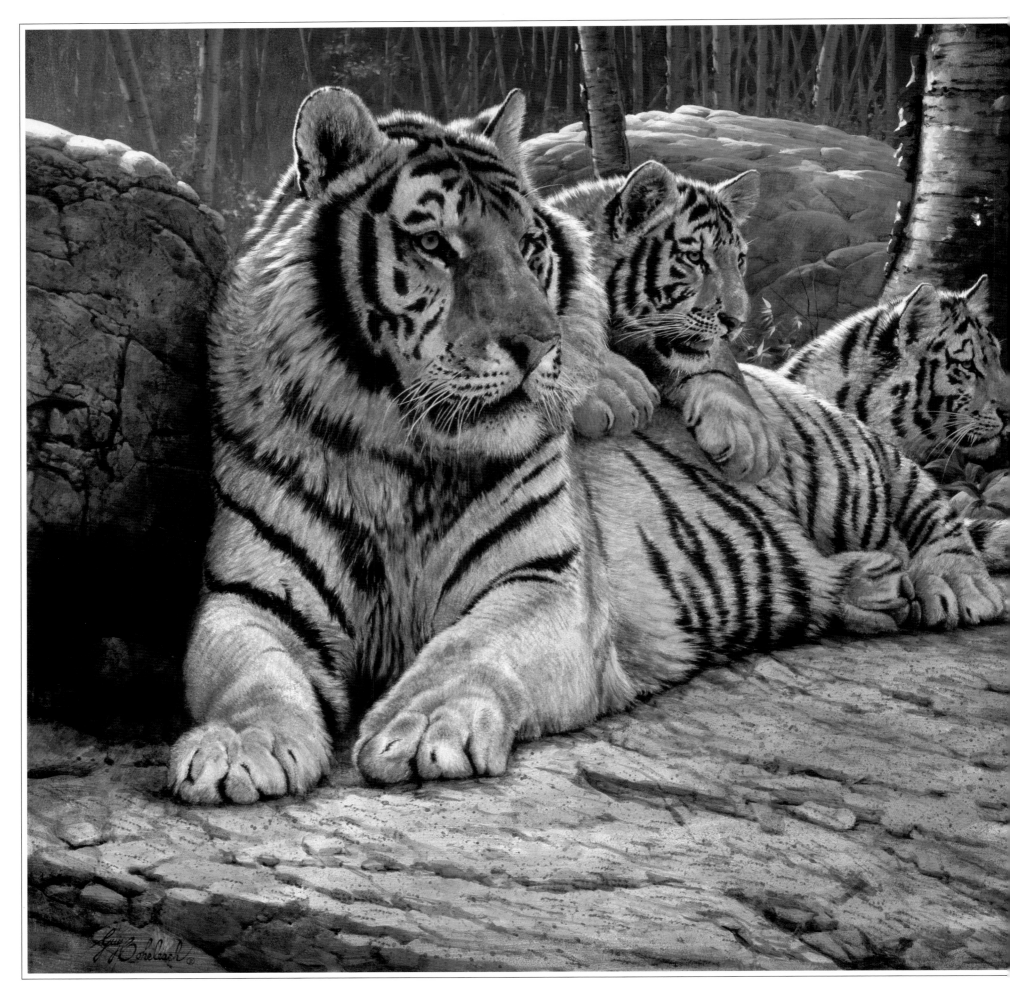

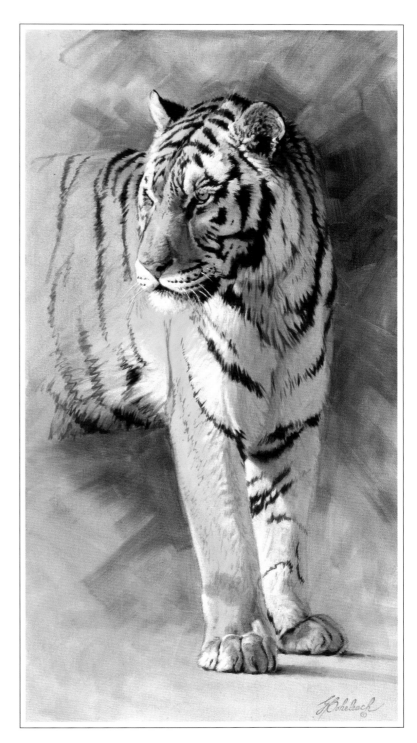

Tiger Study (Bengal Tiger)
Oil on canvas • 36 x18 • 1990

In March, 1990, an exhibition of the paintings of Guy Coheleach opened at the Los Angeles County Museum of Natural History. After an interval there, the exhibition was scheduled to travel to different museums for the next two years. It proved so popular, however, that the exhibition is still on the road (in late 1993), and is booked through 1995.

The exhibition includes about 45 original paintings and a few drawings. **Tiger Study** *was painted especially for that exhibition because I wanted a loose, easel-type painting of a tiger that looked like a painting, not a photograph.*

Siberian Summer (Siberian Tiger Family)
Acrylic on board • 30 x 40 • 1991
Print: 1991

Siberian Summer was painted for a print and was enormously successful and sold out immediately. However, painting a Siberian tiger family presented a few difficulties.

We wanted the cubs to be small, so the season had to be mid-summer. That meant I could not include snow, and adding snow is the easiest way of ensuring that people know it is a Siberian tiger, not a Bengal.

Even in summer, though, Siberians have thicker fur and their colors are not as bright. So even without looking at the title it should be obvious what kind of tigers they are.

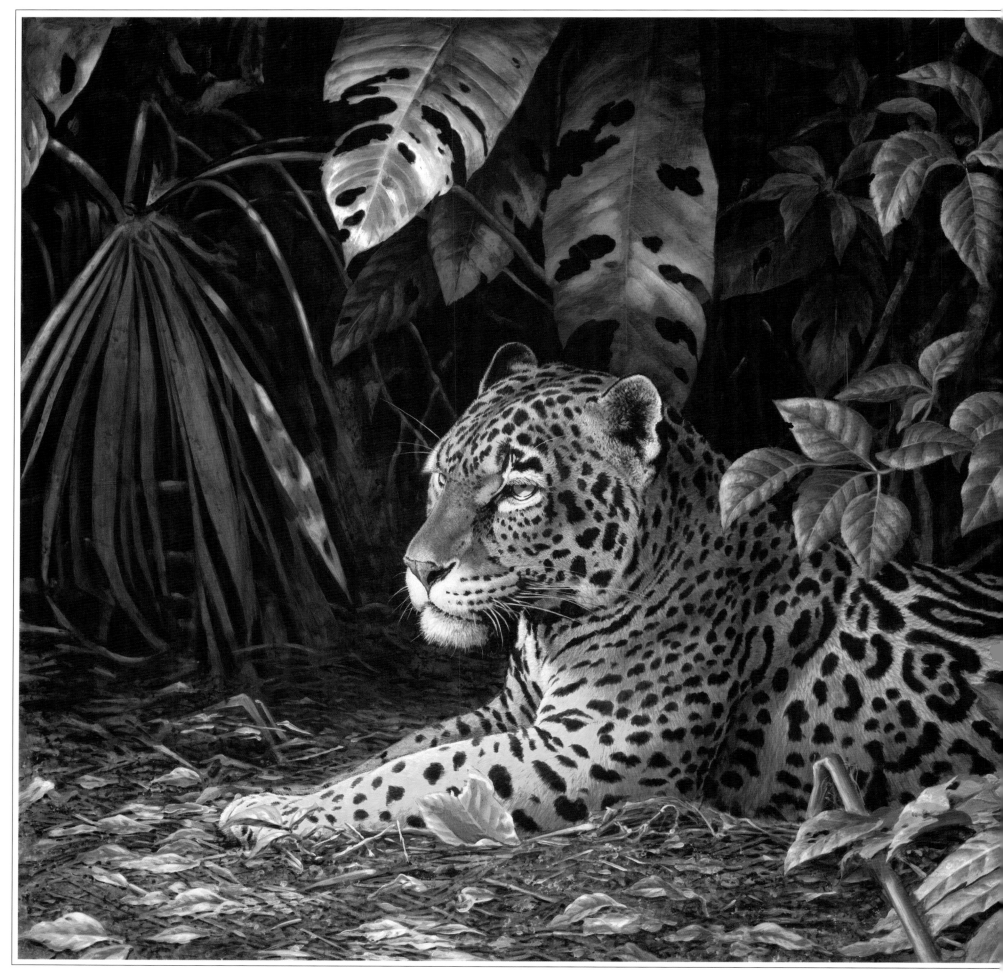

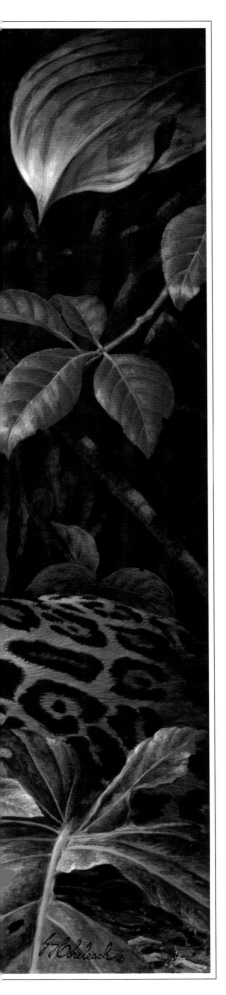

Jungle Cover (Jaguar)
Acrylic on board • 30 x 40 • Print: 1993

This is a highly-detailed painting, created specifically for print publication. Although the jaguar himself is painted in exquisite detail, the background could best be described as *soft focus*. There is no sharp detail to distract the viewer from the jaguar himself, and the lush foliage provides a frame for the big cat.

The jaguar is a very strong, muscular cat with a large bearlike skull. They are incredibly powerful animals and do not have to take their prey into trees like leopards. They simply have no one in their environment big enough to push them around excepting of course man. This fellow is resting in a secluded area ever watchful should any opportunity come his way.

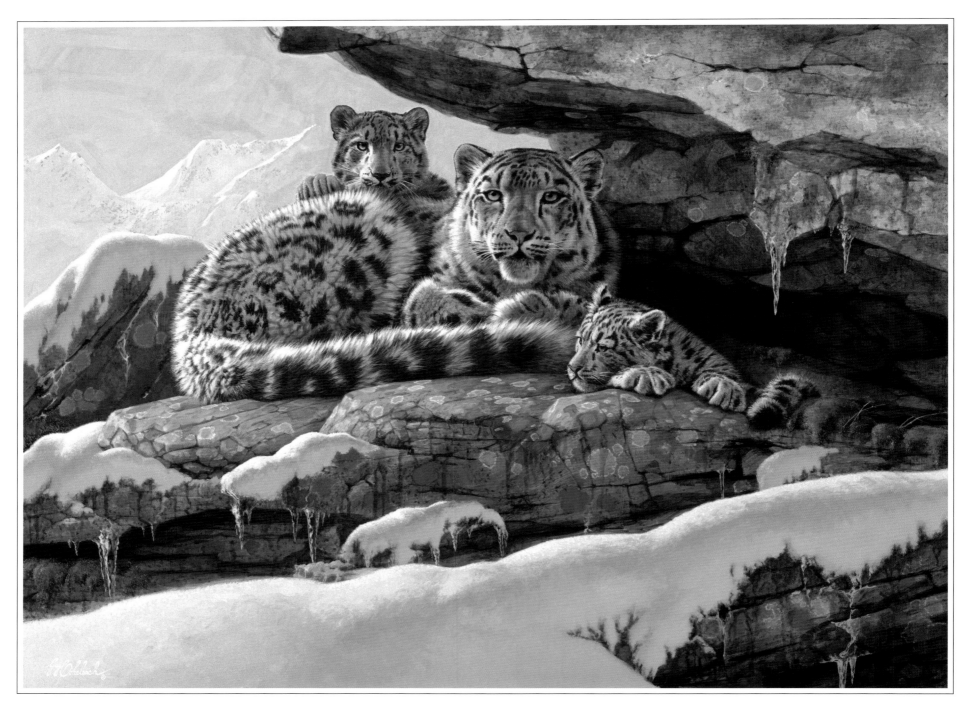

Himalayan Hideout (Snow Leopard Family) • Acrylic on board • 30 x 40 • 1992

Families, especially cat families, are a long-time Coheleach staple. At one point, he decided he should stop painting cute little cubs and kittens and produce real art. About the same time, he learned of one instance where one of his polar bear cub paintings had brought a smile to the face of a little girl who was dying in the hospital.

After that, how could I stop painting them?

Snow leopards are often painted but rarely seen, at least in the wild. In spite of his best attempts, Coheleach has never succeeded in seeing one in the wild state. As a result, he has had to fall back on studying captive specimens — an approach that has its own pitfalls unless you know the differences.

They are great animals, but very shy and elusive. A friend of mine from the New York Zoological Society spent two or three years in the Himalayas and only saw one or two snow leopards in all that time. I've seen them at the zoo many times, I've had one in my studio, and even had one draped over my back, so I'm very familiar with snow leopards.

When it comes to painting them, cats tend to keep a lot of their instincts and native look when they are caged. If they have been fed and looked after, they lose much of the tension, but if you see a big cat in a cage and a bird comes down and starts scolding him, then you'll see that look!

The big differences between a caged cat and a cat in the wild are the look on the face, the hair being rubbed, and the paunched belly. You never see a paunched belly in the wild.

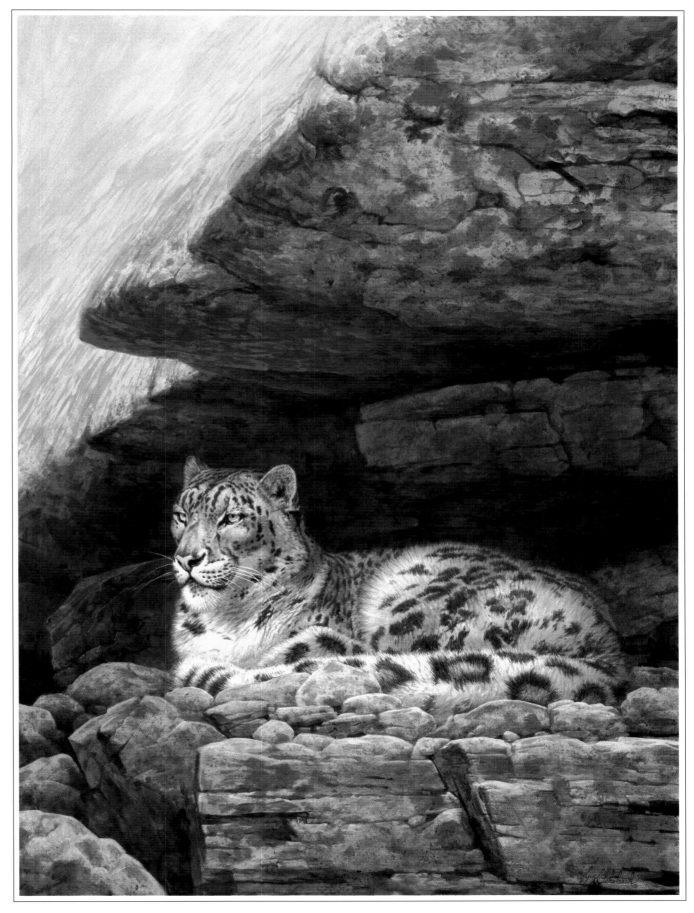

Snow Leopard • Acrylic on board • 40 x 30 • 1991

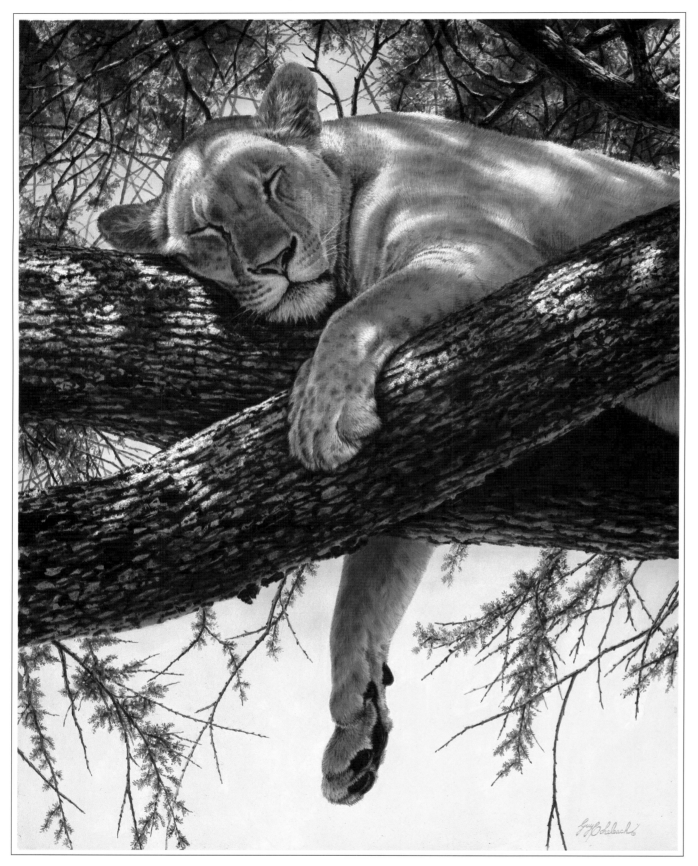

Coheleach is known for his big cats but, after many years of painting them, finding a new pose or a new approach can be difficult. This is an unusual lioness, because she is in a tree. Lions are not known for climbing, but Coheleach has spent so much time in Africa, he seems to know the idiosyncrasies of the big cats in the areas where they occur.

Most lions don't climb trees, although they can all climb angled trees. Those around Lake Manyara (in northern Tanzania) are known for hanging around in the acacia trees. They lounge up there to get away from the ticks and the other insects.

Color study for *Lake Manyara* • 12 x 9

Lake Manyara (Lioness) • Acrylic on board • 40 x 30 • 1992

Hanging Out (Leopard)
Oil on canvas • 30 x 15 • 1989

This painting is part of Coheleach's travelling one-man exhibition that opened at the Los Angeles County Museum of Natural History in 1990, and will be appearing at museums across the country through 1995.

A relatively small work, done in oil on canvas, it is perhaps the definitive Guy Coheleach painting.

This is very, very loosely painted — yet there's nothing really missing.

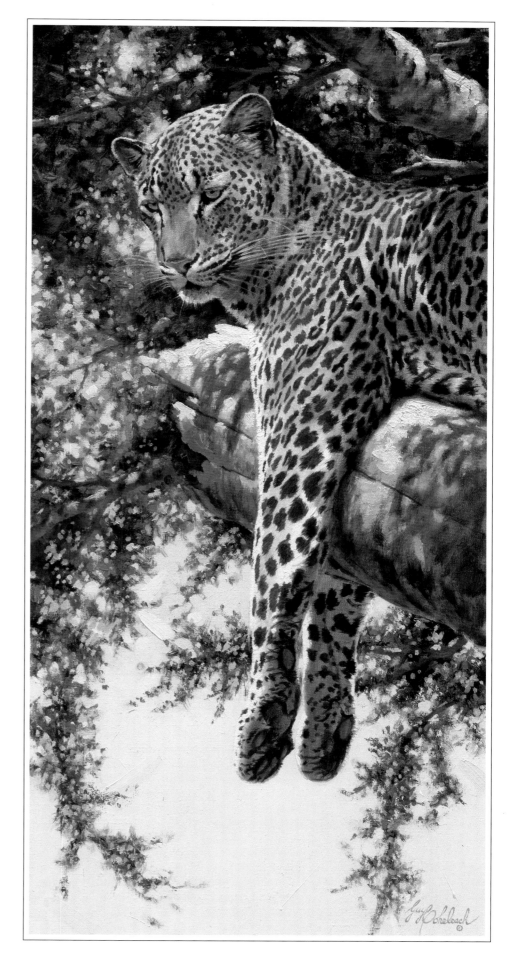

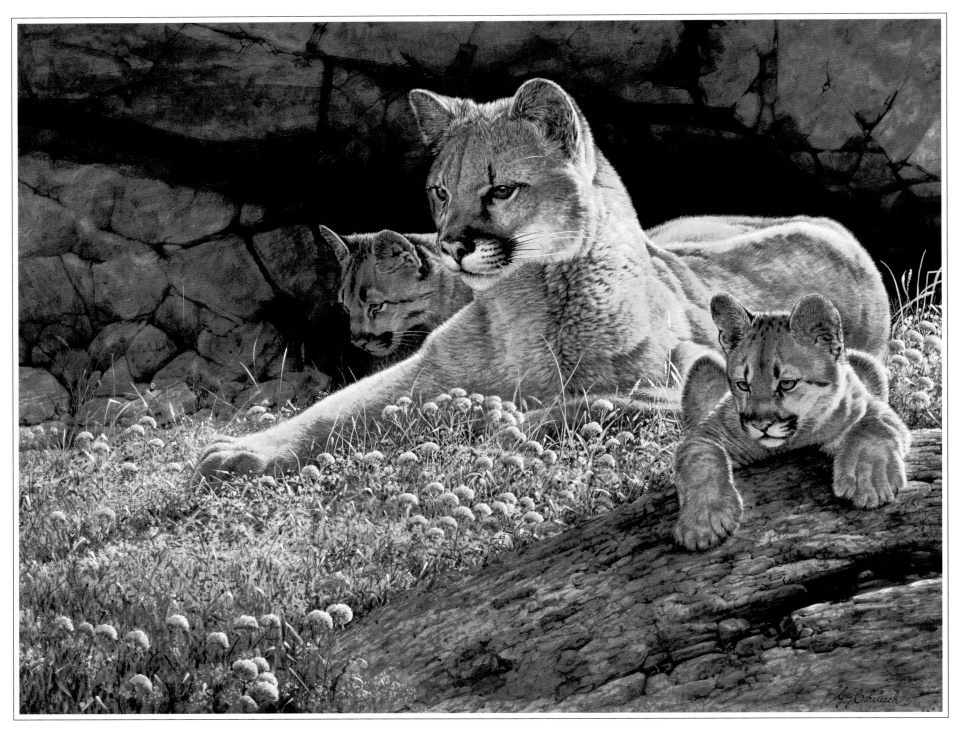

Young Mother (Puma Family) • Acrylic on board • 30 x 40 • 1990 • Print: 1990

When Coheleach is discussing subject matter, a big cat is almost always in the offing, and cat families are invariably popular.

To make this family different from others, Coheleach chose to depict the mother as a cat barely into adulthood herself. Aside from the very young, feminine appearance of her face, there are other, subtle differences as well.

This is a young mountain lion with her first brood. She still has the fuzziness on her face and a very, very slight hint of some of the spots from kittenhood.

The print sold out, almost immediately.

Snow Leopards
Oil on canvas • 36 x 18 • 1988

Snow leopards are among the most difficult animals in the world to observe in the wild, partly because of their limited numbers, but mostly because of their reclusive nature and the rarified altitudes at which they live. Anyone who has actually seen a wild snow leopard has earned the privilege. The clouded leopard of Southeast Asia is just as rare, just as difficult.

The closest I've come is seeing the back end of a clouded leopard as it disappeared in the distance.

To see them, you have to be prepared to devote a lot of time — and by that I mean months, if not years — living in their habitat.

Anyone who has seen a snow leopard, or a clouded leopard in the wild is really privileged.

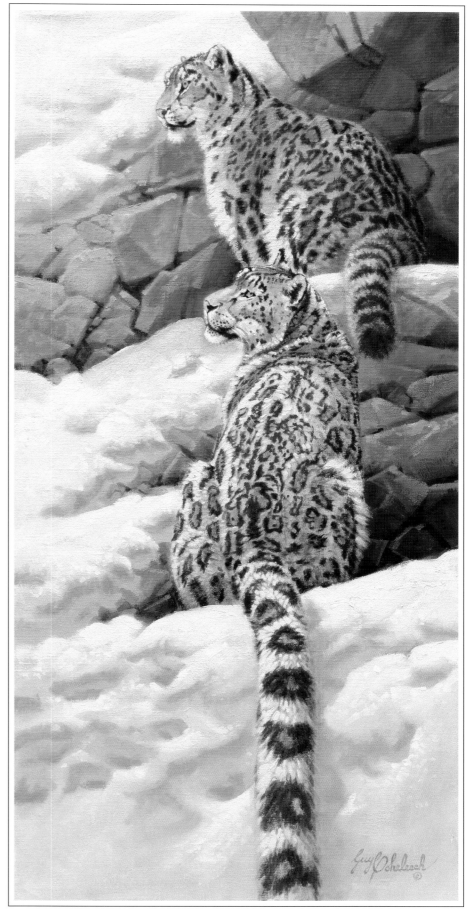

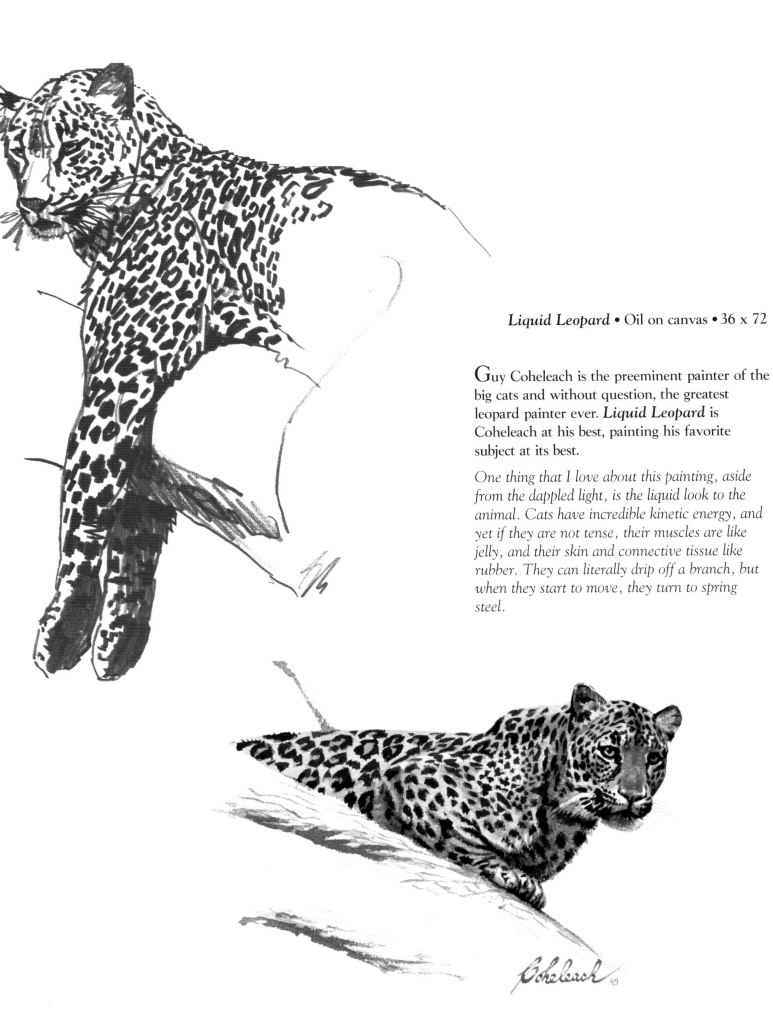

Liquid Leopard • Oil on canvas • 36 x 72

Guy Coheleach is the preeminent painter of the big cats and without question, the greatest leopard painter ever. *Liquid Leopard* is Coheleach at his best, painting his favorite subject at its best.

One thing that I love about this painting, aside from the dappled light, is the liquid look to the animal. Cats have incredible kinetic energy, and yet if they are not tense, their muscles are like jelly, and their skin and connective tissue like rubber. They can literally drip off a branch, but when they start to move, they turn to spring steel.

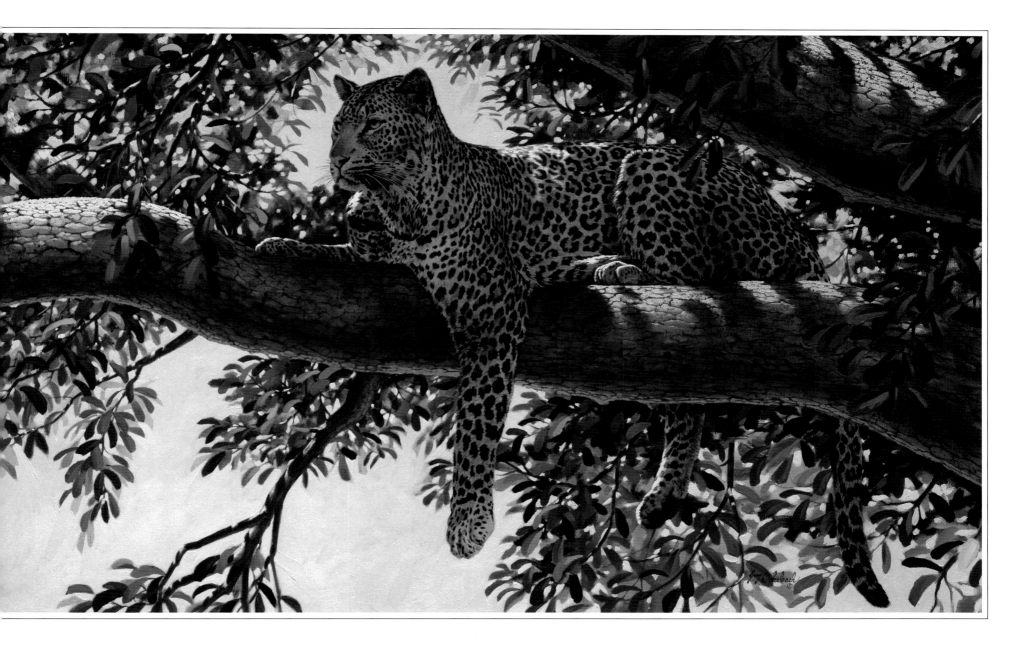

Overleaf:
Bachelor Evening • Oil on canvas • 36 x 72 • 1987

In the late 1980's Coheleach experimented with the theme of two adult male lions in various settings. Altogether, he created three paintings. The first two, relatively small, works (12 x 24 approximately) were donated to Safari Club International and its chapter in Ontario, Canada, for fundraising. The third and largest was painted for a client who saw the first one, liked it, and asked Coheleach if he could do a similar but larger painting. The result was the strongest painting of the three. In it, Coheleach, makes use of very strong lighting — sunset, when lions begin to hunt — to obtain some special effects.

Because of the way I put the light on it, I could really model the bodies and shape the heads. When you have strong light you can play around with cool and warm colors, too.

It is not uncommon to see adult male lions moving together. Here they are setting out for the evening's hunt. If one male can take down a big buffalo these two should have an easy task on any hapless prey that they come across.

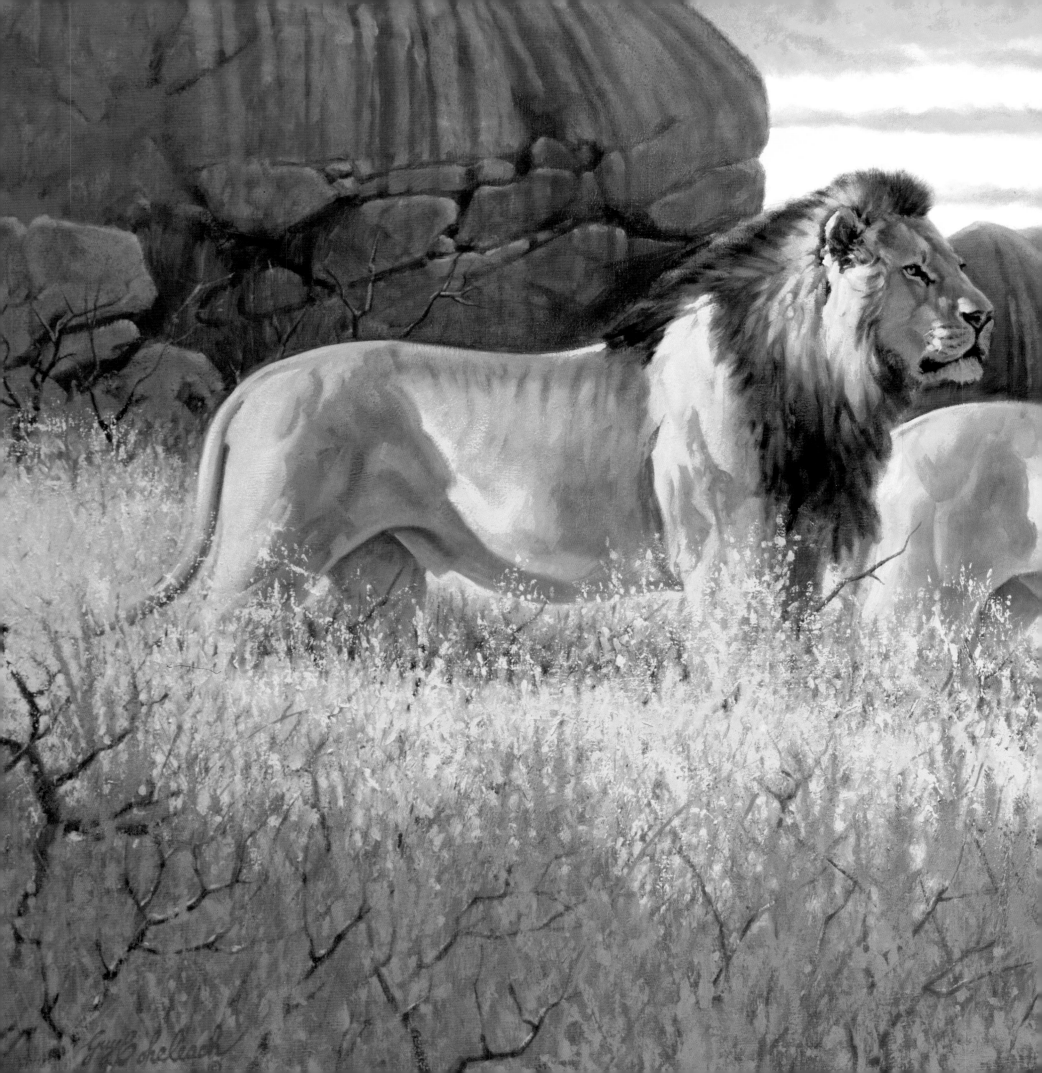

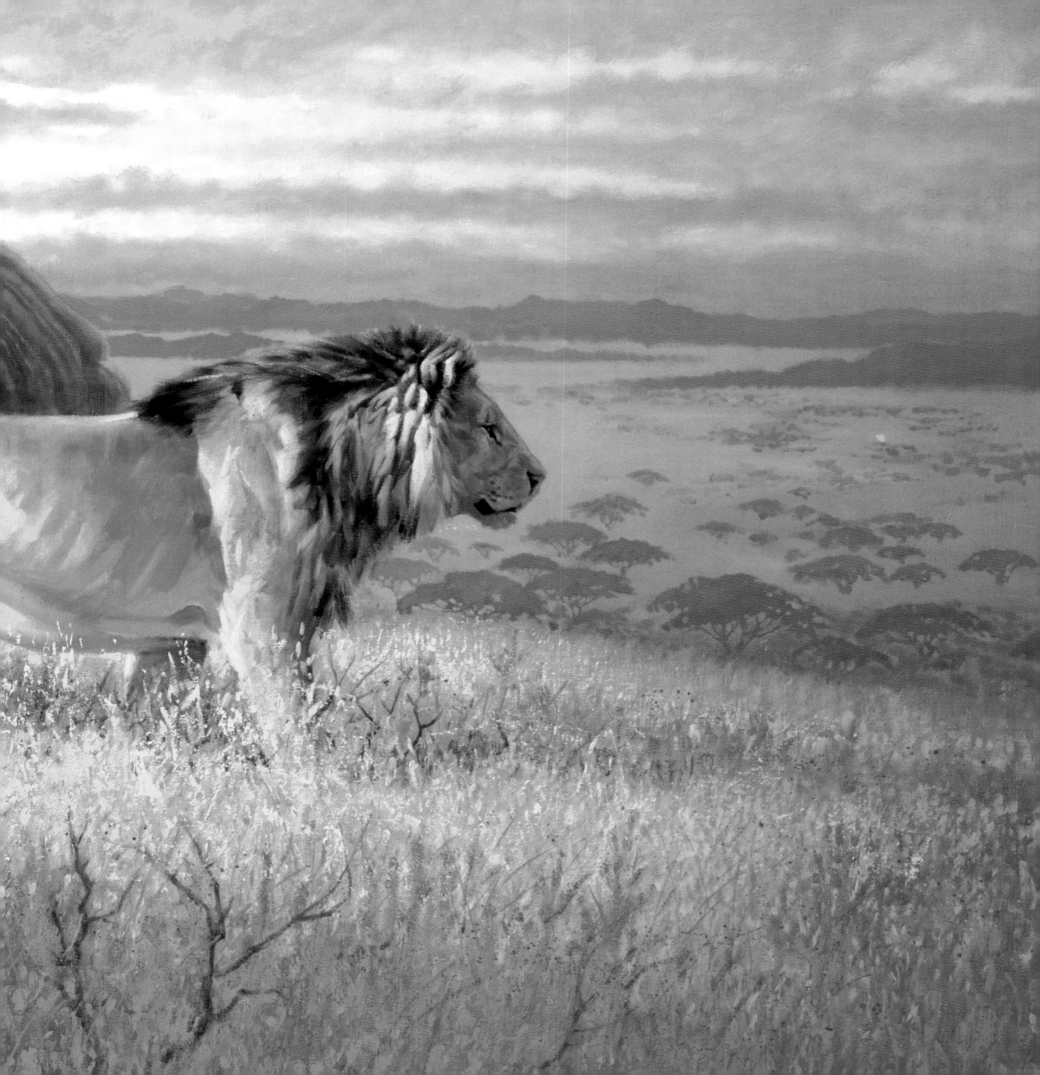

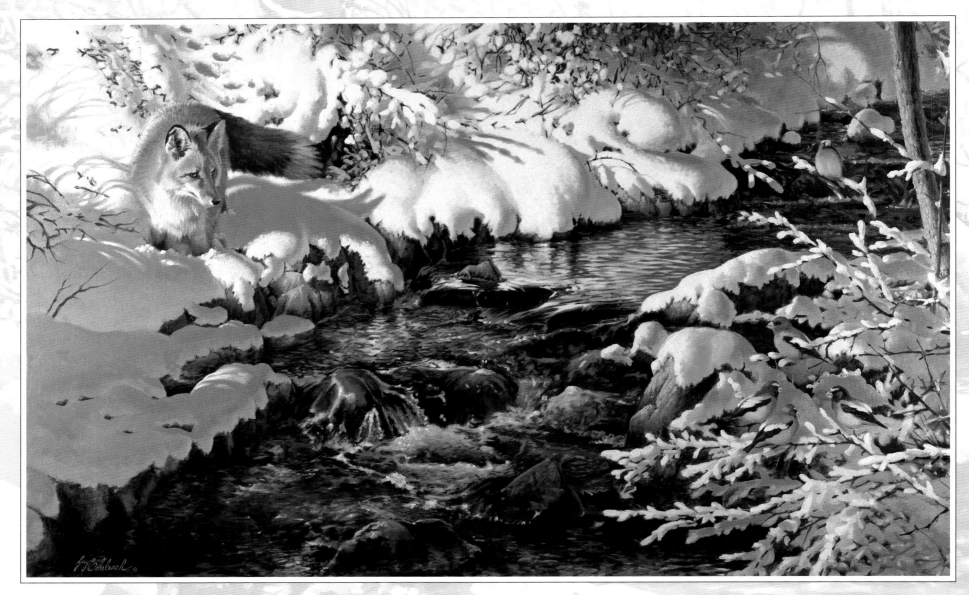

January Morning Fox • Oil on canvas • 36 x 60

*T*his is yet another example of how a red fox can warm up a snow scene. It is also another example of some of the streams in our part of New Jersey. The evening grosbeak are quite safe.

FOXES, ETC.

*I love the warmth
of a red fox
in the cold snow.*

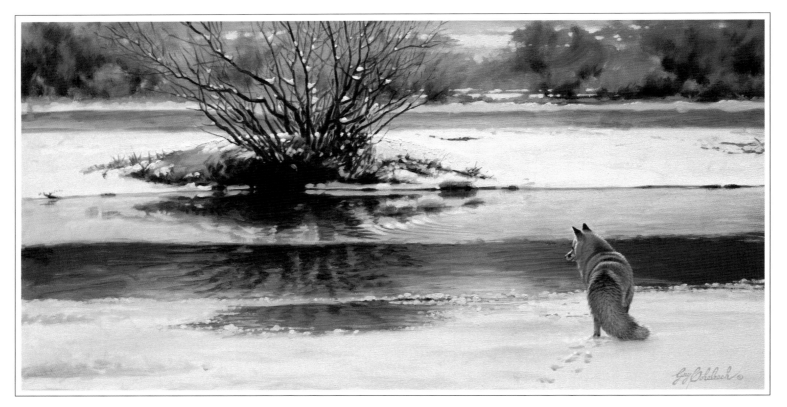

Captree Fox • Oil on canvas • 12 x 24

If you are wondering about the size difference between this painting and the one in my previous book it is because this is another painting on the same theme. Captree is a section of southern Long Island from which this scene came.

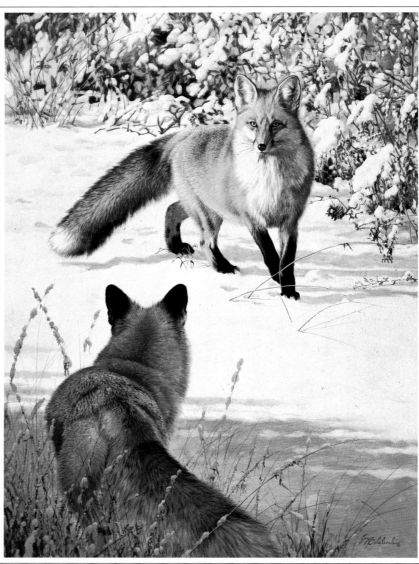

Friend or Foe (Foxes)
Acrylic on board • 40 x 30

These two are deciding whether the other is a potential mate or a competitor. The idea of using two foxes provides the opportunity of showing a wonderful winter foxtail from the rear.

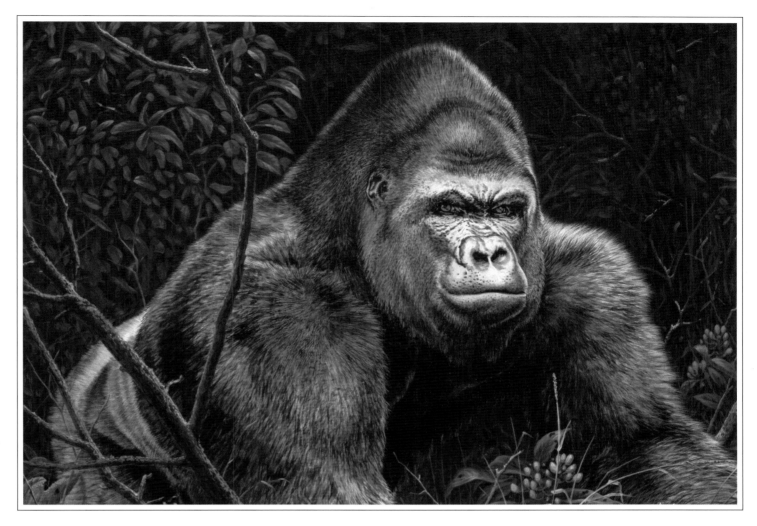

Colossus • Acrylic on board • 22 x 30

For some reason I just wanted to paint a gorilla. The awesome Colossus at the Zoo in Gulf Breeze, Florida was more gorilla than I could resist and hence the painting.

There is a window that is obviously very strong where people can view him with only inches of separation. I shall never forget the sight of this huge animal gazing at a small child whose body was not even as large as Colossus's head.

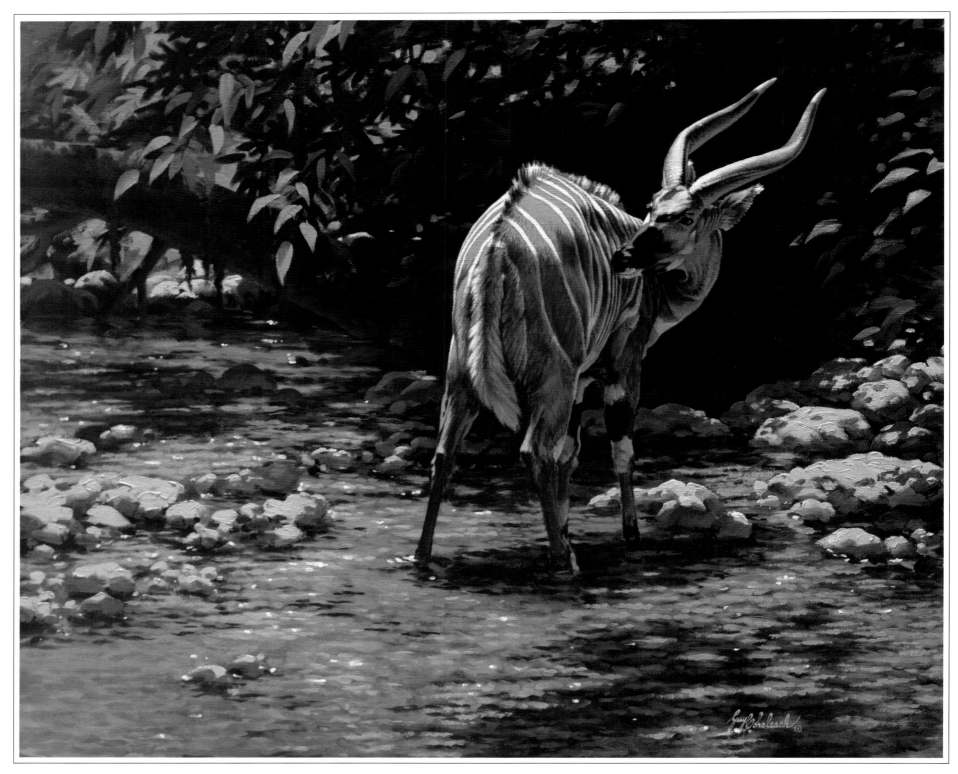

Bongo • Oil on canvas • 22 x 30 • Print: 1986

The bongo is a very elusive antelope of the Central African rain forests. This painting shows one preening in the heat of the day at a stream after satisfying its thirst.

This is the way I like to paint. The sun is directly overhead. It is hot, and you know it's hot. The bongo is standing in the stream. The strong shadows denote heat, but also provide, along with the vegetation, a nice contrast that accents the animal's colors.

More than just placing the animal in its habitat, Coheleach reveals its character. The secretive, reclusive, shadowy mood of this painting reflects the bongo's legendary elusiveness.

This particular bongo, however, has been seen by thousands since it was published by the Dallas Safari Club in 1986.

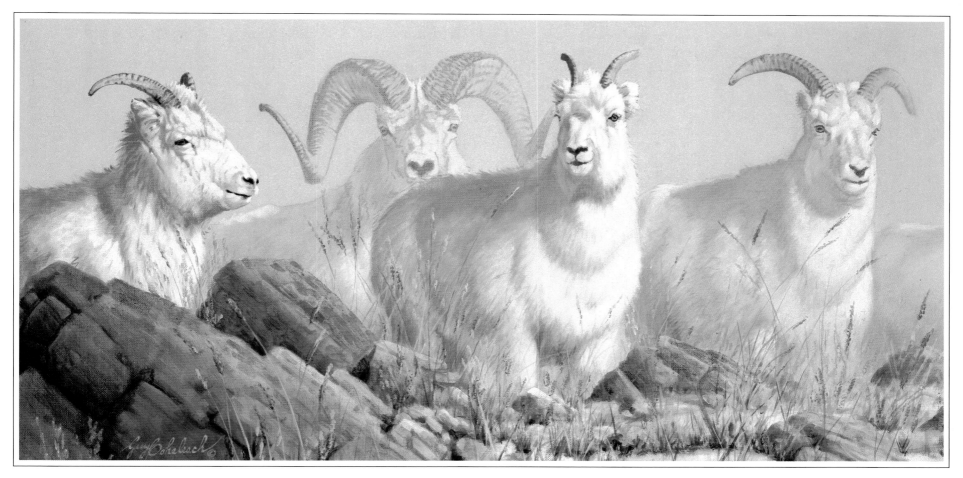

In the Clouds • Oil on canvas • 12 x 24

Most sheep seem to be mountain climbers. The dall sheep live in Northwest Canada and Alaska. This painting attempts to show a group which commonly haunt these heights literally in the clouds.

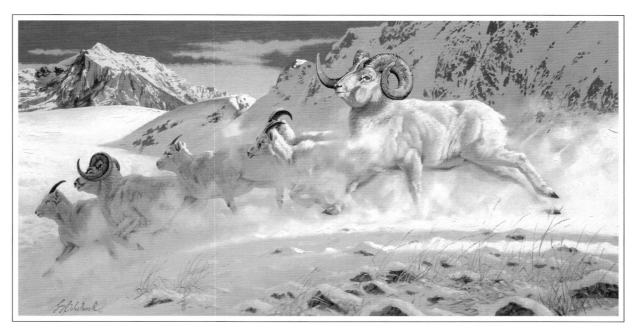

Through the Pass • Oil on canvas • 18 x 36

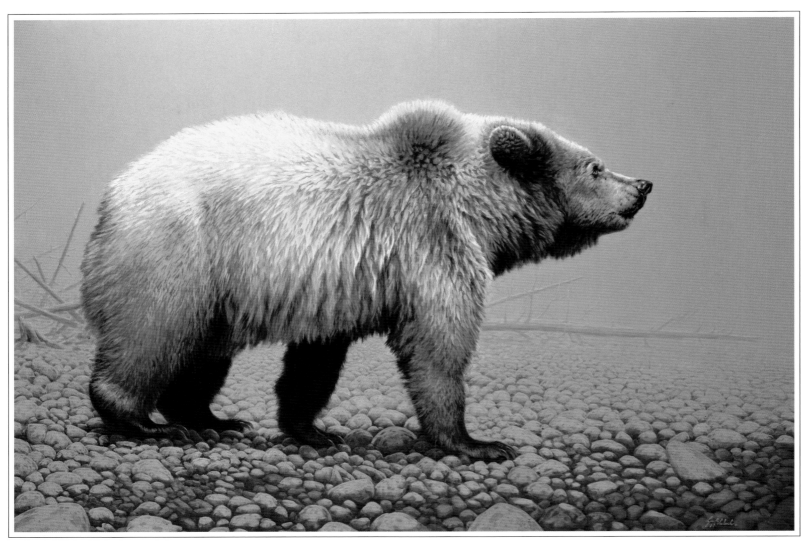

The Golden Bear (Yellow Tipped Coastal Grizzly Bear) • Oil on linen • 60 x 84 • 1987

This huge painting was commissioned by Jack Nicklaus, a long-time client and Coheleach collector, and hangs in the lobby of Golden Bear Plaza in North Palm Beach, Florida.

The main concern here was making a yellow tipped grizzly look like a **golden bear**.

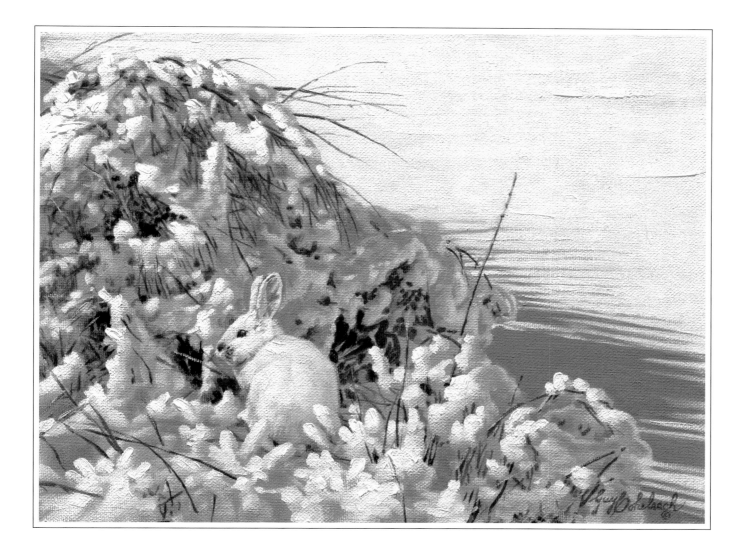

Edge of the Frozen Lake (Rabbit)
Oil on canvas • 9 x 12 (miniature)
1991

Scant Seclusion and *Edge of the Frozen Lake* are both paintings of rabbits in the snow, painted the same size and at the same time.

I had a particular palette out, I was working up ideas and liked two of them, so I did two paintings.

As you can see, the pigments are the same. Some people don't realize that you use completely different palettes for painting different scenes and seasons. Compare these two with a painting like **Etosha Chase** *(p. 80), and you see what I mean. The blues are not the same blues, the browns not the same browns. This is another dividend of field study: you get to know tones and color temperature.*

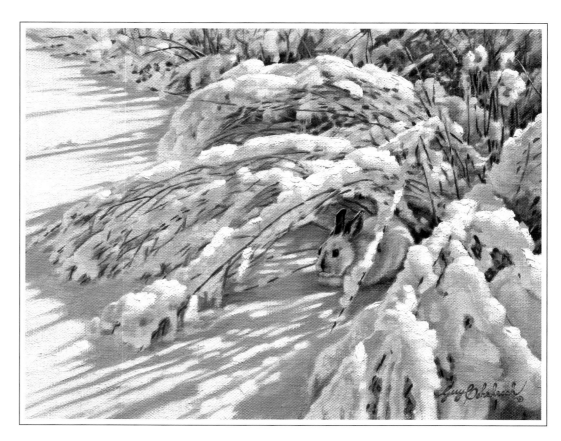

Scant Seclusion (Rabbit)
Oil on canvas • 9 x 12 (miniature)
1991

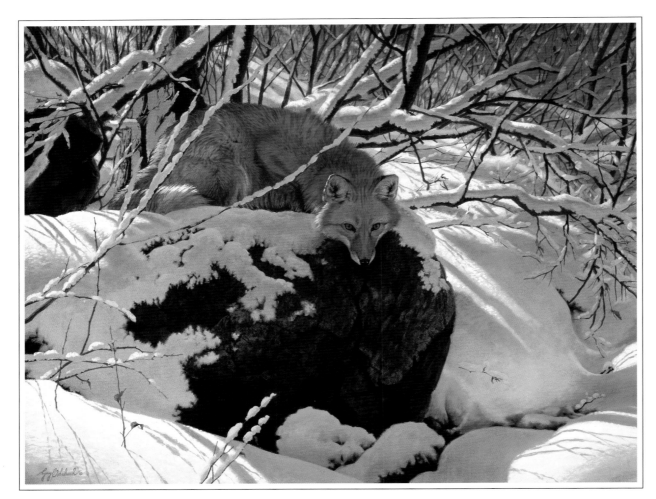

Foxfire (Red Fox) • Oil on canvas • 30 x 40 • 1991 • Print: 1992

For painters as for composers, a good idea is rarely exhausted with one treatment, and Coheleach frequently paints variations on one theme, exploring it in different ways. This painting is a good example: He painted a miniature first, followed by *Foxfire*, which was printed by Mill Pond in 1992, and then *Foxfire II*, which was in The Society of Animal Artists 1993 Exhibition.

In this case, trying different approaches was enjoyable for Coheleach because of the subject matter.

I love painting snow and I love painting foxes in the snow, because they always provide a highlight that really warms up a cold winter painting.

If I have a good idea and it works, I have no problem reworking it a number of times, exploring different approaches. Generally, the idea for going further than just one painting is that frequently I'm torn — should I do it this way, or that way? — So I finally do it both ways just to see which is better. Very often, they are both good.

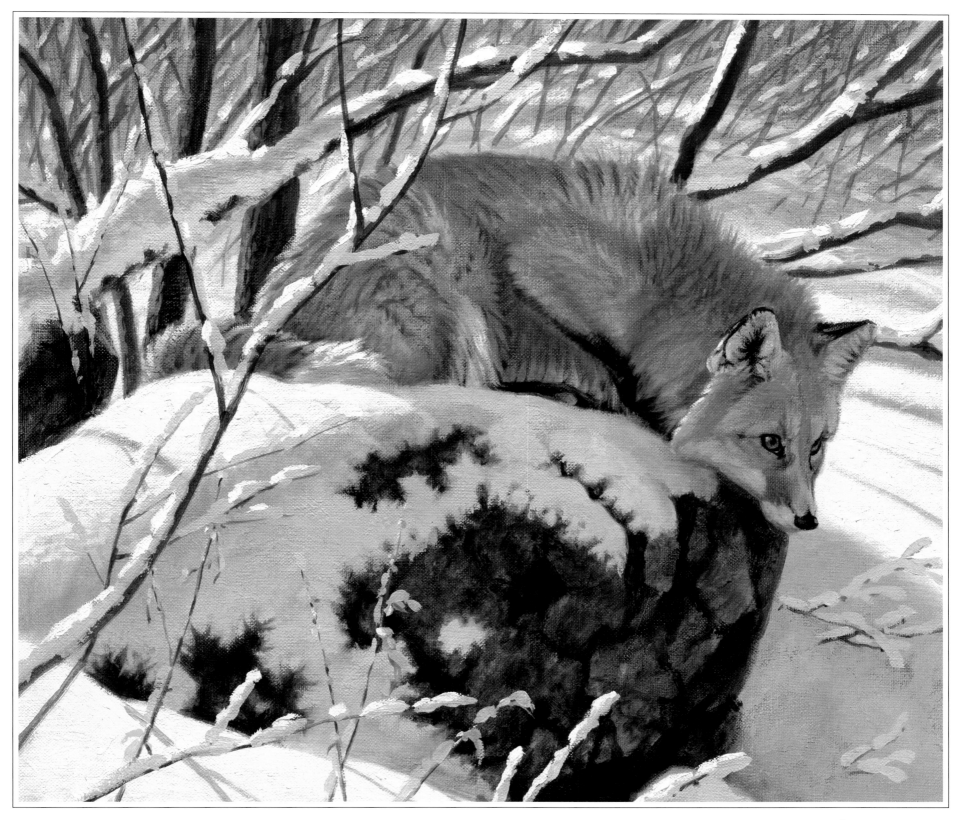

Foxfire II (Red Fox)
Oil on canvas • 18 x 22 • 1992

Out of the Blue is a large, painterly, impressionistic work that was included in The Society of Animal Artists 1993 Exhibition. It is Coheleach's favorite way to paint — no obvious detail, but a great deal of texture. The response of people attending the exhibition shows that wildlife art lovers do not always demand photographic detail in paintings.

They had a ballot among people attending the travelling exhibition to choose their favorites, and thousands voted. This painting placed fifth, and it was the only impressionistic painting in the top 20. The other 19 were very detailed, hair-and-feather paintings or sculptures.

I was very pleased. Plus the fact that I love painting like that. It is a large painting and you can really see the texture of the paint. In some places, the paint is half an inch thick and there's no detail at all in it.

I was sitting with Bob Kuhn looking at slides when they came and asked me what the title was. I said, "I don't know, I'll just pick one out of the blue." Bob said, "that's a good one right there," so that's what it became.

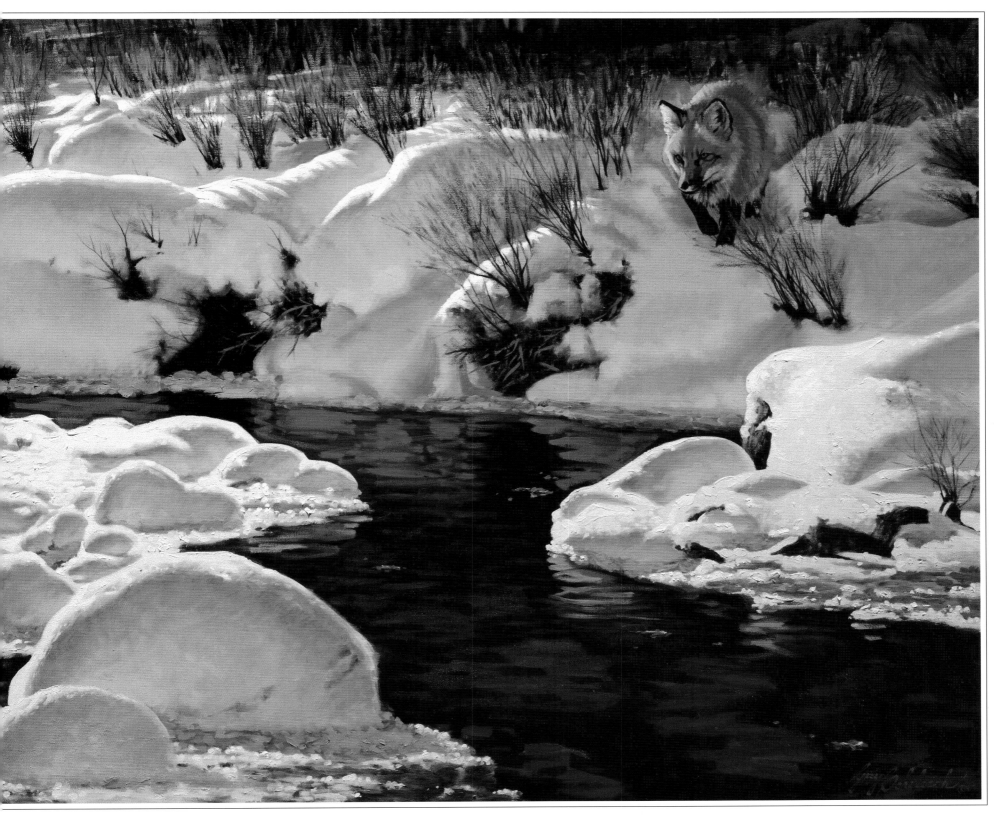

Out of the Blue (Red Fox) • Oil on canvas • 30 x 50 • 1992

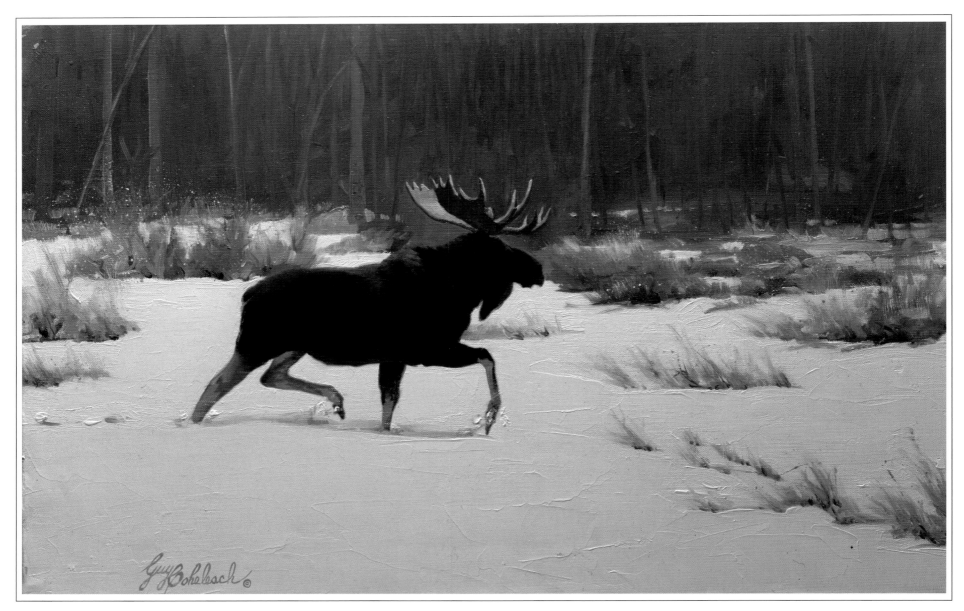

Lone Moose • Oil on canvas • 12 x 24 • 1977

This painting was inspired by a winter trip to Algonquin Park in Ontario, Canada. We were watching ravens when behind us we noticed this lone bull moose trudging through the snow.

I never seem to be comfortable painting gray winter days. I always want to put more color into the painting than I actually see.

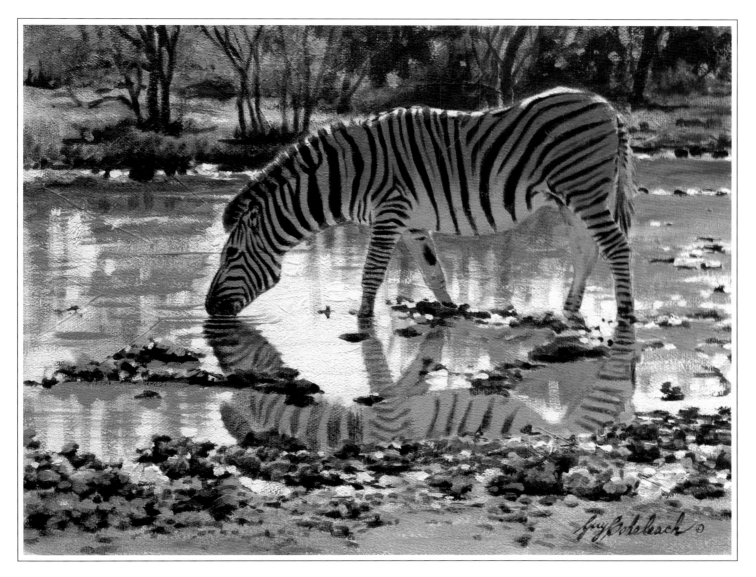

Etosha Zebra
Oil on canvas
9 x 12

*In the painting **Chobe Chase** (p. 81), there is a leopard chasing an impala. That incident happened about an hour after we a saw this zebra drinking. Whereas this painting is very similar to what we saw, the leopard painting (**Chobe Chase**) was completely reconstructed from a different viewpoint and the young kudu was changed to an impala.*

The End

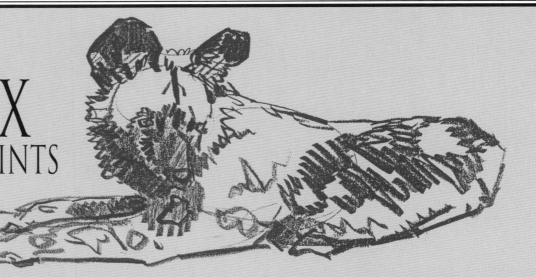

APPENDIX
LIST OF PLATES & PRINTS

Natural History Museum of Los Angeles
Los Angeles, California
Mar. 9, 1991 - Dec 1, 1991

R. W. Norton Art Gallery
Shreveport, Louisiana
Jan. 12, 1992 - Mar. 8, 1992

Glassmere Wildlife Park
Nashville, Tennessee
April 4, 1992 - May 31, 1992

Cincinnati Museum of Natural History
Cincinnati, Ohio
June 15, 1992 - Aug. 15., 1992

Ward Museum
Salisbury, Maryland
Aug. 31, 1992 - Dec. 31, 1992

Court House Cultural Center
Stuart, Florida
Jan. 22, 1992 - Mar. 21, 1993

Central Park Wildlife Conservation Center
New York, New York
Apr. 1, 1993 - June 30, 1993

International Wildlife Museum
Tucson, Arizona
July 12- Oct. 2, 1993

Dayton Museum of Natural History
Dayton, Ohio
Jan. 14, 1994 - Mar. 13, 1994

Houston Museum of Natural History
Houston, Texas
May 1 - Aug. 31, 1994

Cleveland Museum of Natural History
Cleveland, Ohio
Sept. 9, 1994 - Jan. 8, 1995

Blauvelt Museum
Oradell, New Jersey
Apr. 8 - June 30, 1995

FILMS

Art for the Corkscrew Swamp, Frame House Gallery, 1969

The Bald Eagle and Guy Coheleach, Unit One Films, 1973

Quest: An Artist and his Prey, Regency House Art, 1976

BOOKS

The Big Cats, The Paintings of Guy Coheleach, Nancy Neff, Harry Abrams, NY, NY, 1982

Wildlife Artists at Work, Patricia Van Gelder, Watson Guptill Publications, NY, NY, 1982

The Big Cats, The Paintings of Guy Coheleach, Nancy Neff, Abradale, NY, NY, 1984

The African Buffalo, Anthology, National Sporting Fraternity, Clinton, NJ, 1984

The African Elephant, Anthology, National Sporting Fraternity, Clinton, NJ, 1985

Wildlife Painting Techniques of Modern Masters, Susan Rayfield, Watson-Guptill Publications, NY, NY, 1985

Painting Birds, Susan Rayfield, Watson-Guptill Publications, NY, NY, 1988

Coheleach, Terry Wieland, Briar Patch Press, Camden, SC, 1989

The African Lion, Anthology, National Sporting Fraternity, Clinton, NJ, 1989

Birds in Art The Masters, Anthology, Leigh Yawkey Woodson Art Museum, Wausau, Wisconsin, 1990

African Wildlife in Art, David Tomlinson, Clive Holloway Books, London, 1991

SELECTED MAGAZINE ARTICLES

The African Leopard, Anthology, National Sporting Fraternity, Clinton, NJ, 1993

William and Mary Review, Guy Coheleach; Aesthetic Values of Wildlife Painting, Prof. Scott Whitney, Spring 1975

Readers Digest, Painted As They Are, Picture Story, August 1977

Sports Afield, The Reach of an Artist, Tom Brakefield, Feb. 1979

Connaissance de la Chase, Guy Coheleach, J. A. Capiod, Jan. 1979

Prints, Guy Coheleach, Gretchen Schmitz, Summer 1979

Sporting Classics, Eye of the Hunter, Pat Robertson, May-June 1984

Fins and Feathers, Guy Coheleach, Chuck Wexler, Oct. 1986

Game Coin, Guy Coheleach, Anne Fornora, March 1987

The Conservationist, Guy Coheleach, Anne Fornora, Nov.-Dec. 1987

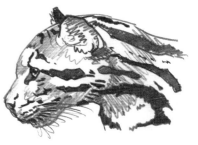

Wildlife Art News, Guy Coheleach, A Brush with Excitement, Judy Hughs, Sept. 1987

Focus, Rochester Museum, Guy Coheleach's Wildlife, Deborah Raub, Fall 1988

Terra, Los Angeles Museum, The Wildlife Paintings of Guy Coheleach, Robin Simpson, Winter 1990

U S Art, Hall of Fame, Our Four Inaugural Members, Kathi Neal, July-Aug. 1991

Wildfowl Art, Ward Museum, Walk on the Wild Side, Joseph Forsthoffer, Fall 1992

Wildlife Art News, Interviews Guy Coheleach, Terry Wieland, Jan. - Feb. 1994

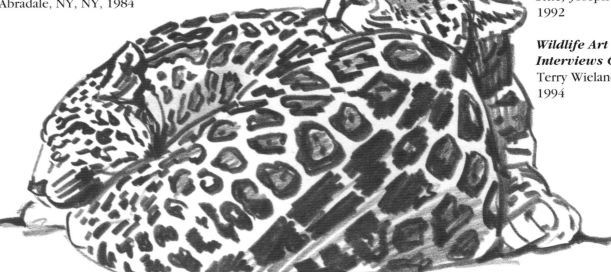